MARIA TROLLE'S
UNIVERSE

COLORING BOOK
A COLLECTION OF FAVORITES
AND NEW ILLUSTRATIONS

Gibbs Smith

This year marks seven years since I was asked to illustrate a coloring book for adults. Since then, there have been a total of seven coloring books. In the world of fairy tales, seven is a magic number. So this particular year—seven years and seven books later—it feels appropriate in many ways to stop and sum up my coloring book universe.

In total, I have illustrated more than six hundred coloring book pictures, which is incredible when I think about it. From the beginning, I mostly drew plants, birds, and animals, but over time I also illustrated people and fairy-tale creatures. I seem to do my best work when I am free to explore themes and motifs.

As you will discover when you flip through the book, my drawing style has changed little over the years. Sometimes it has been more naturalistic, sometimes more stylized and simplified. Sometimes I have worked with more black, and sometimes the lines have been fewer. I have edited some of the illustrations I selected for my *Universe* a bit because I liked the basic idea, but thought that some parts needed adjustment, simply because I developed and grew as an illustrator during these past seven years. Under each picture I have written the title of the original coloring book it comes from and, to the delight of many, I've added page numbers to make it easier to find what you're looking for in the index. I have also created twenty-two new illustrations for this volume.

I am so infinitely happy and grateful for those of you who paint and color in my books. Seeing my black-and-white drawings come to life through your amazing imaginations puts me in a good mood every time. Thank you for following along with me on this trip.

I hope you have many wonderful colorful moments in my *Universe*.

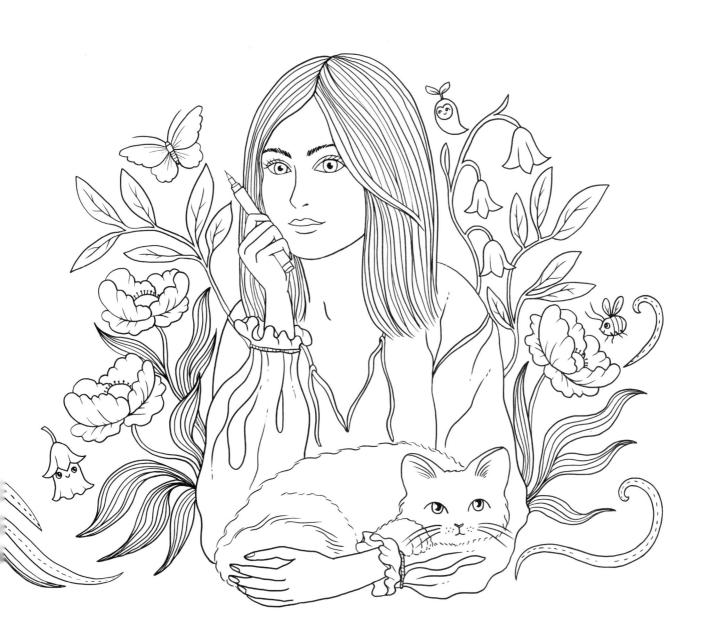

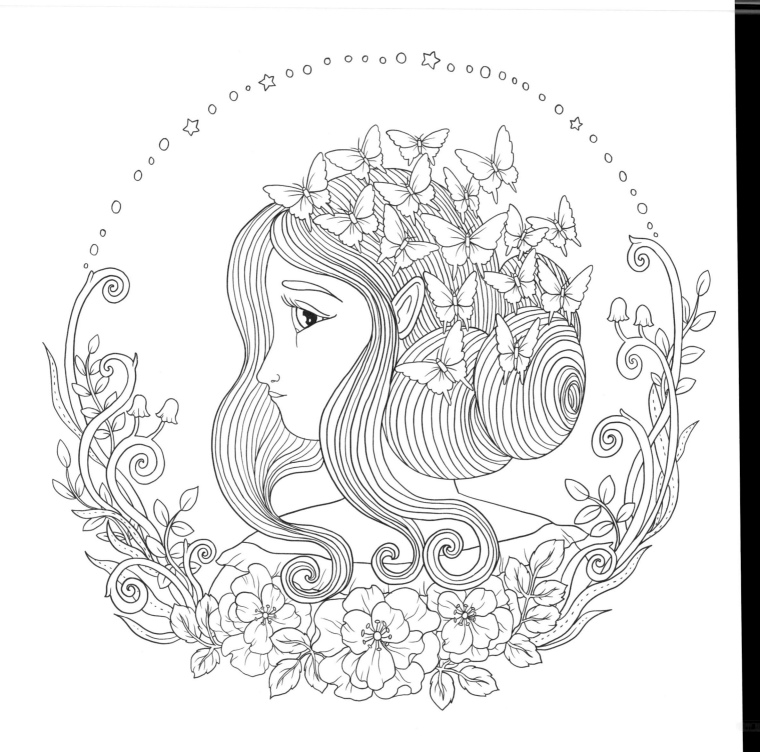

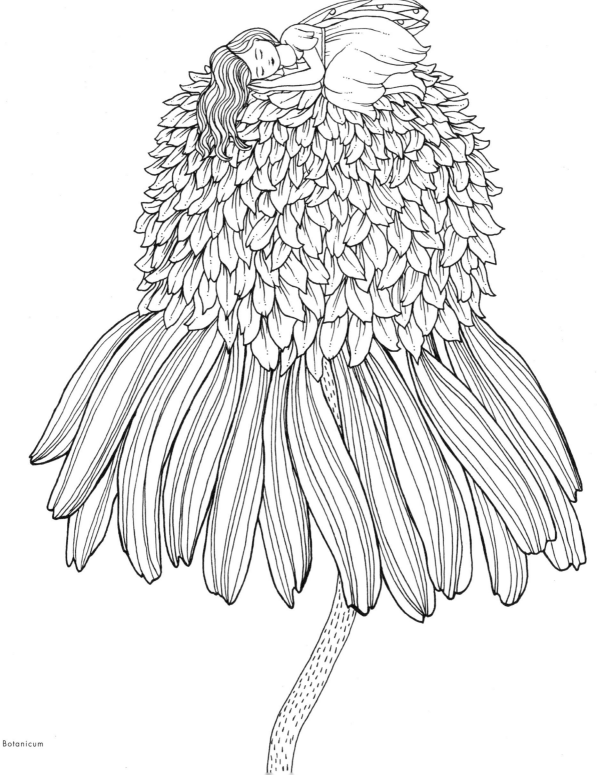

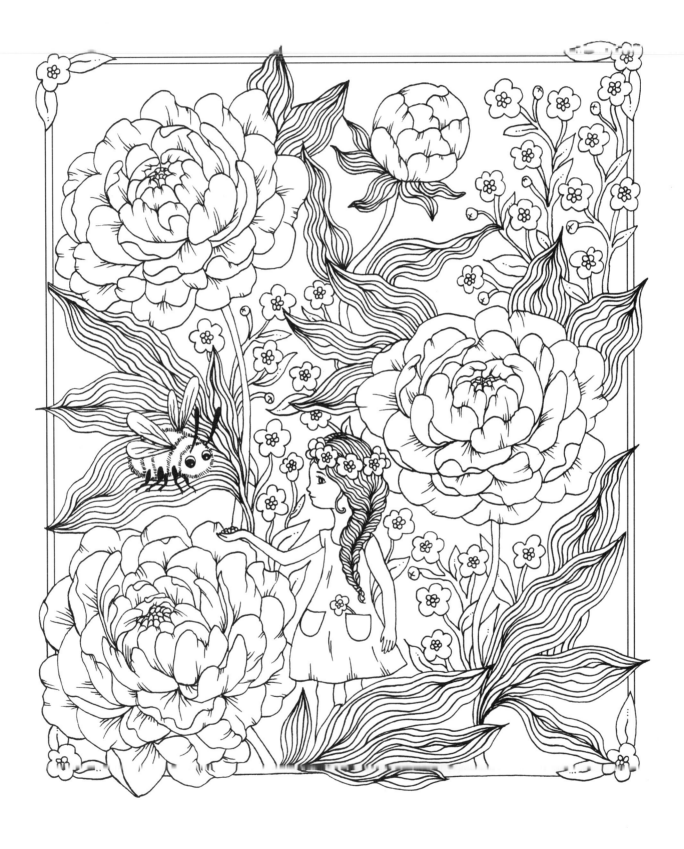

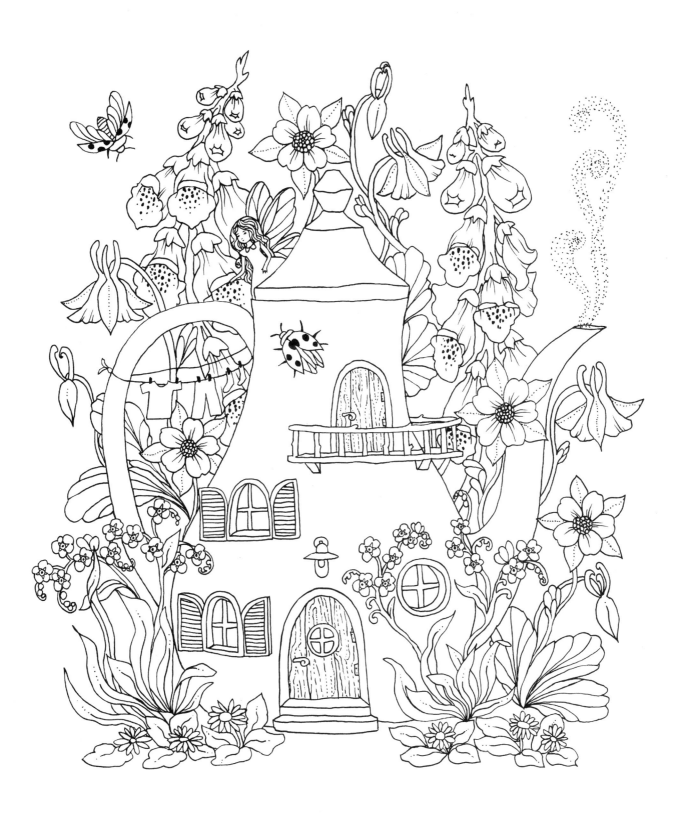

Flora

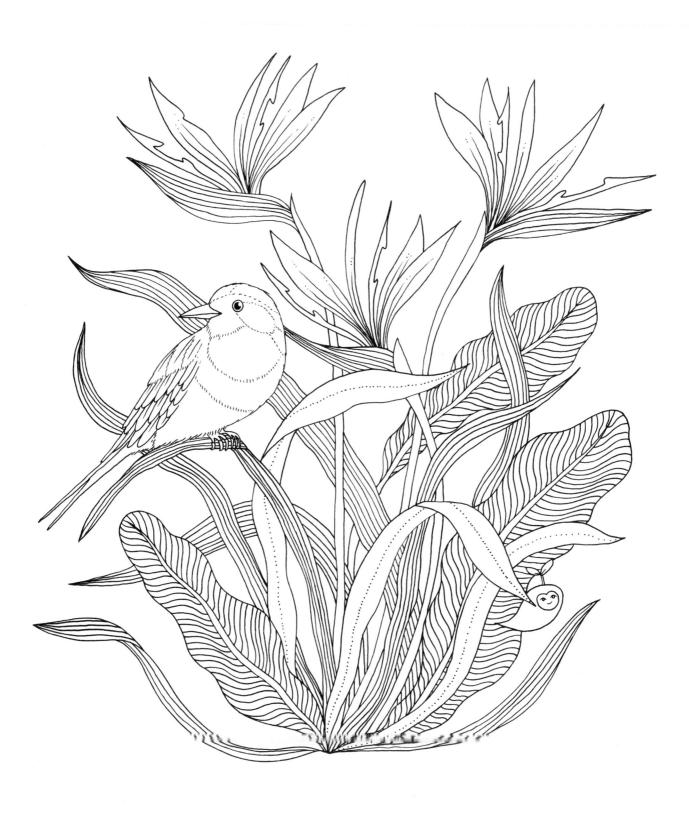

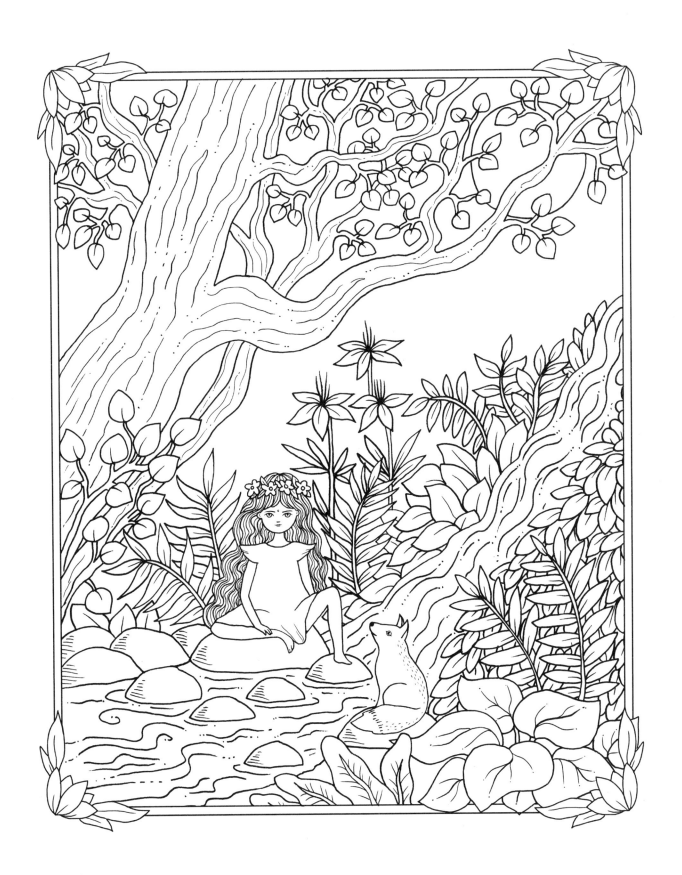

Luna

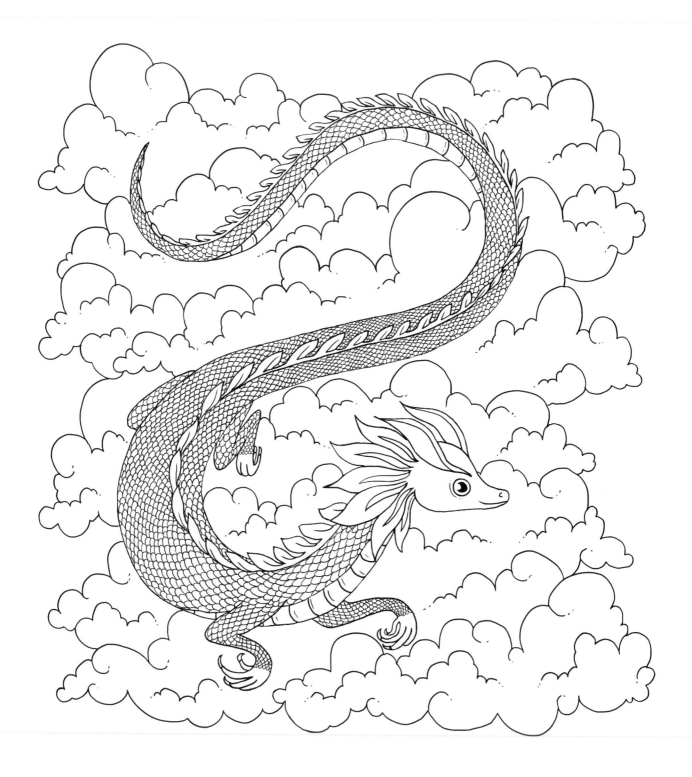

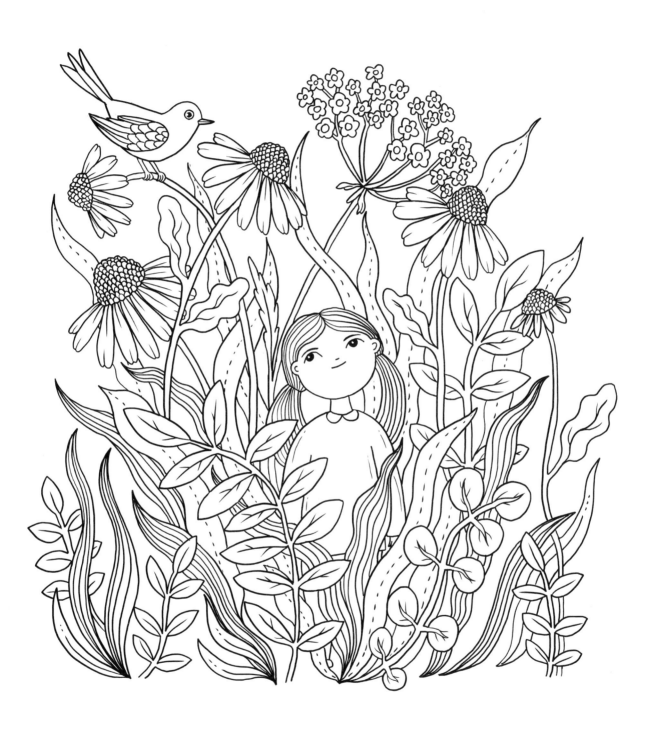

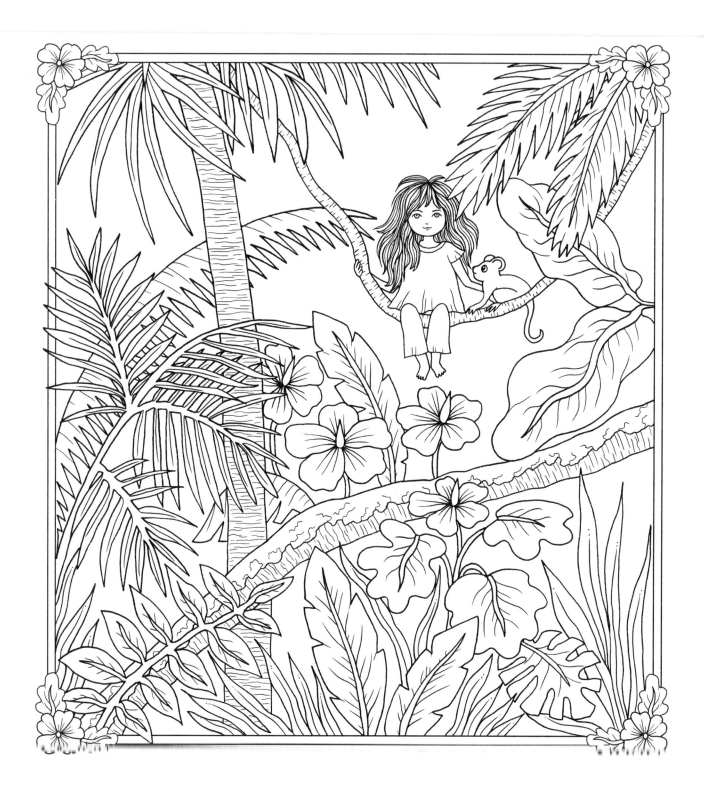

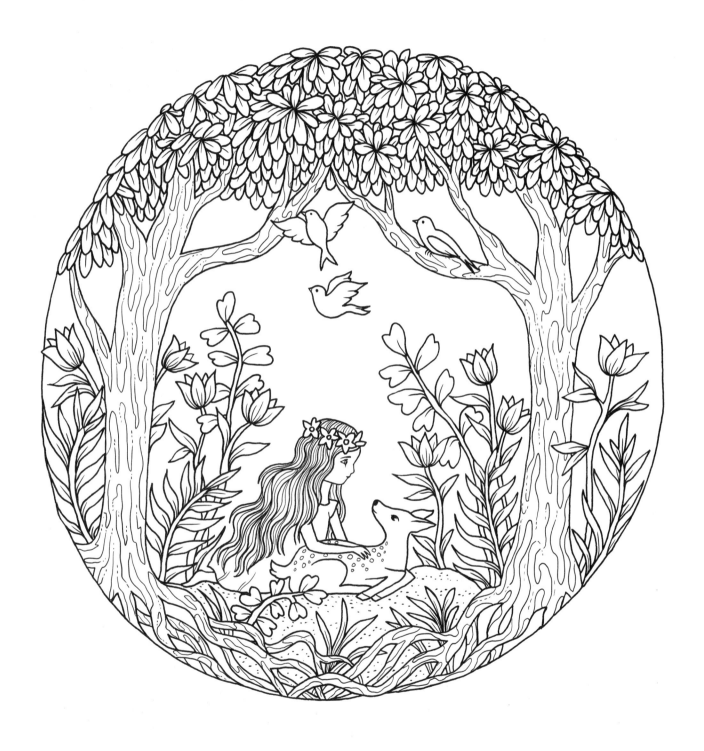

Luna

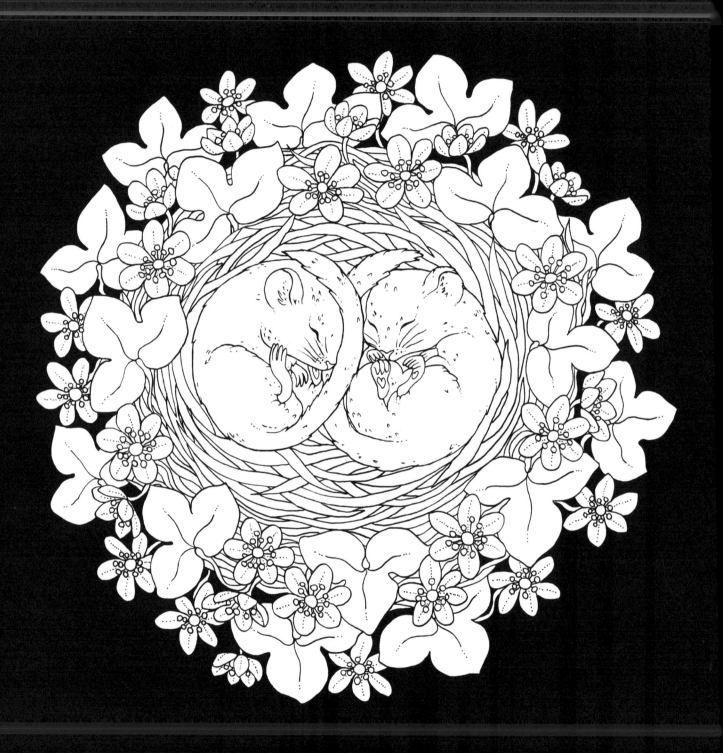

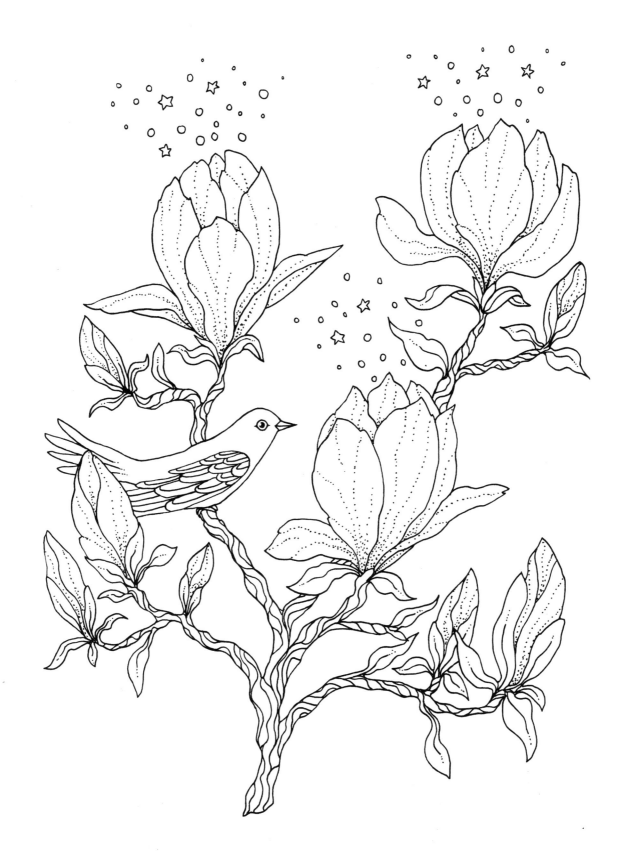

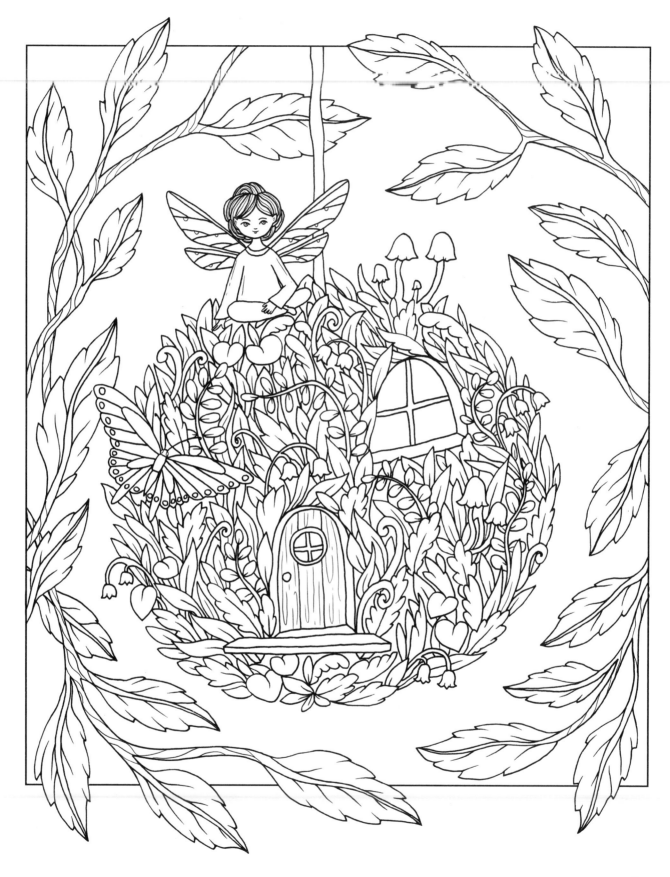

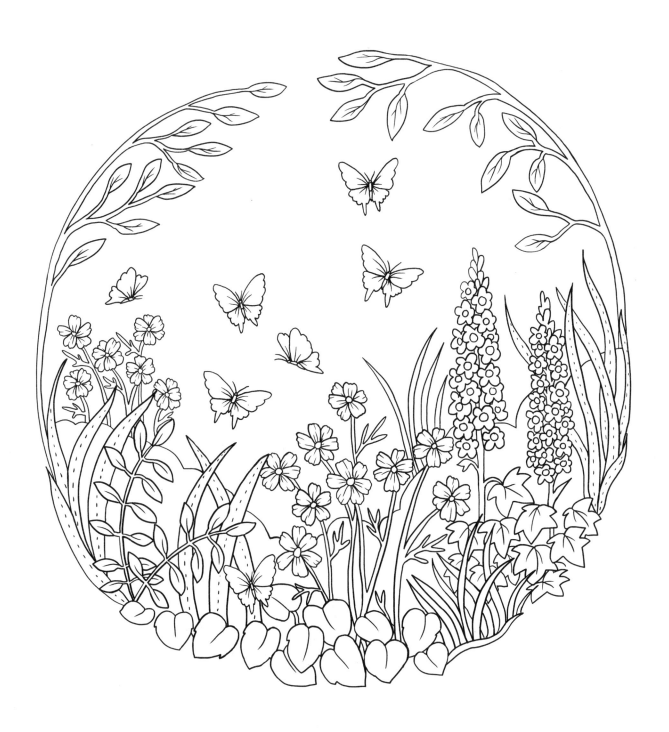

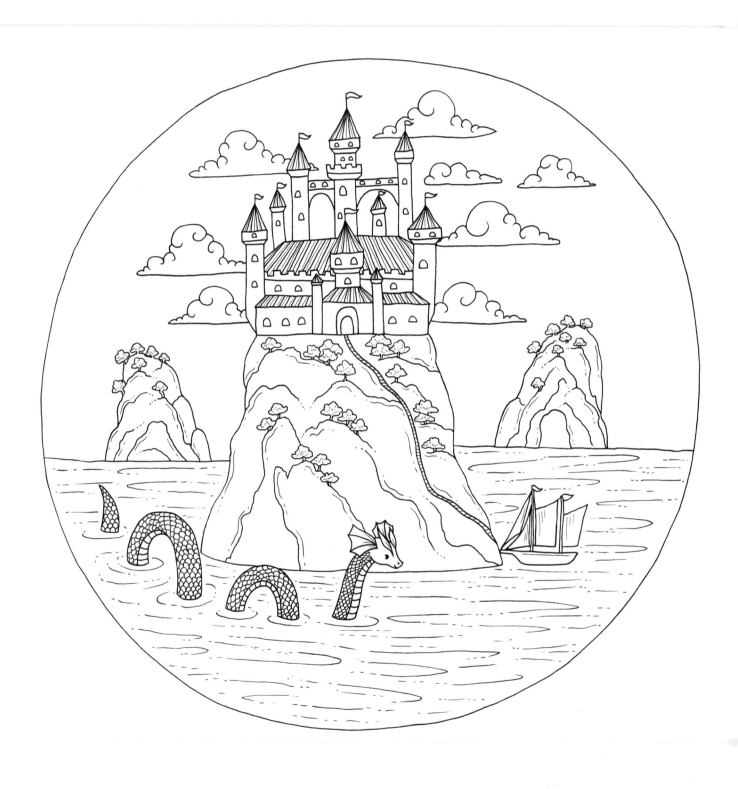

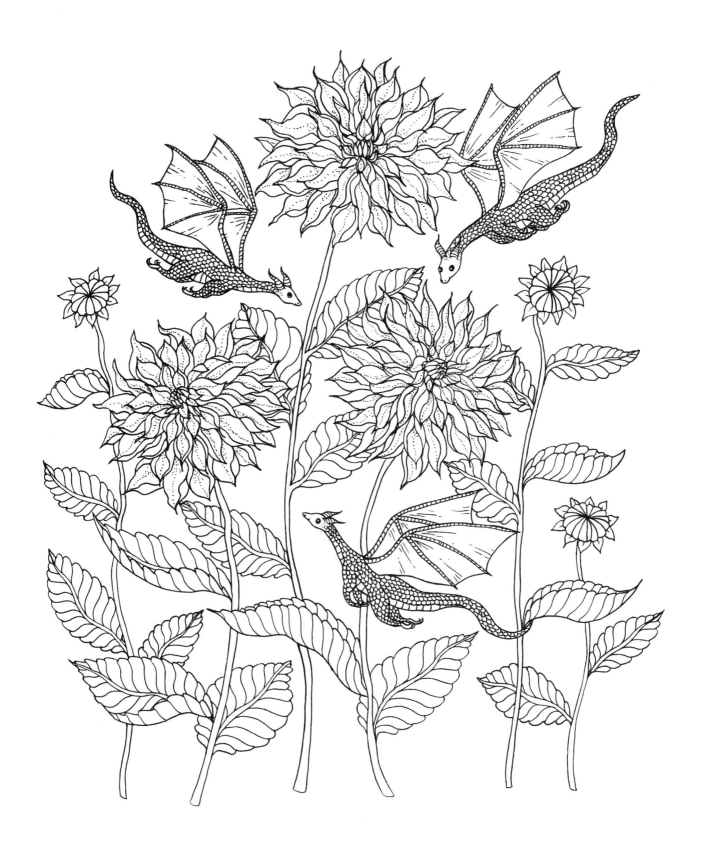

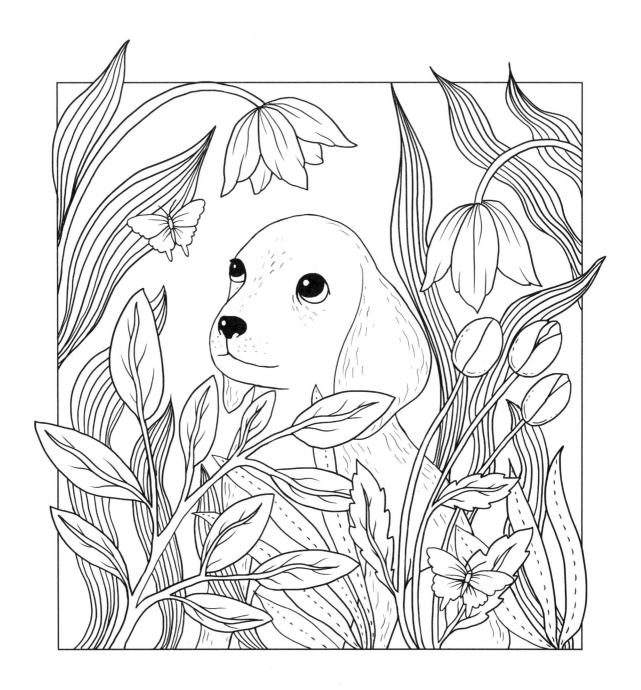

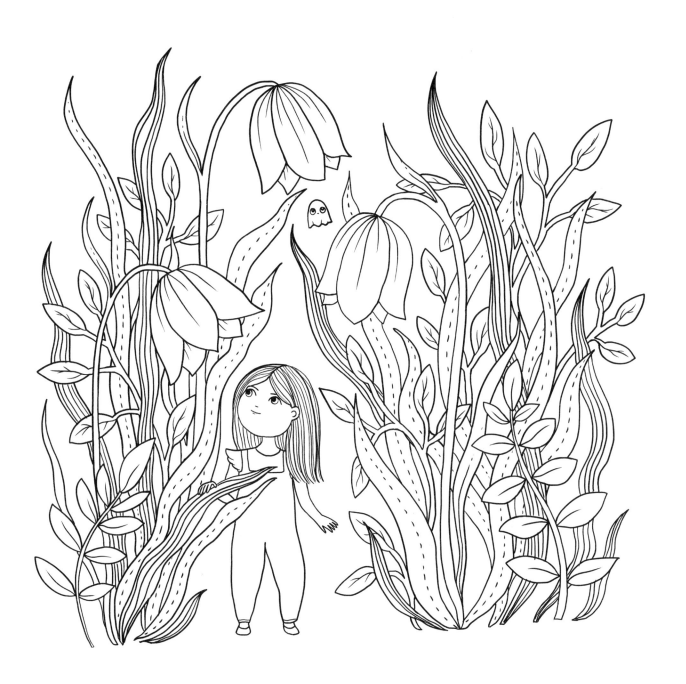

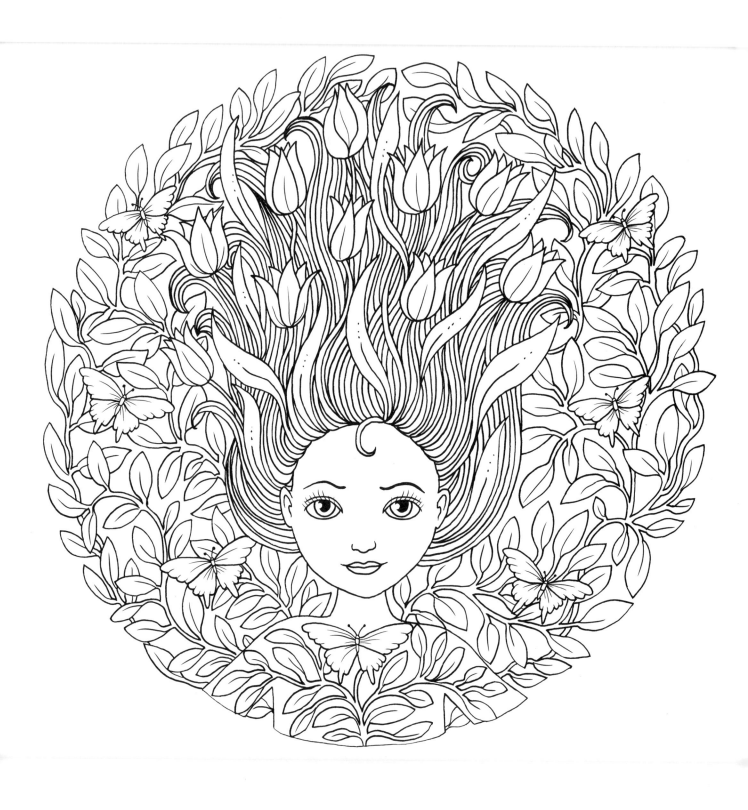

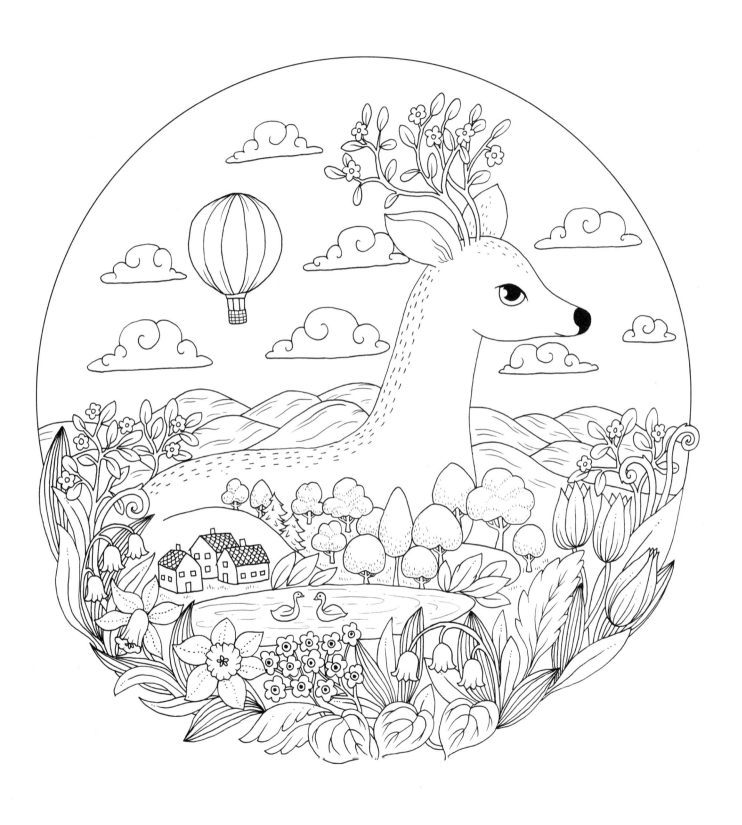

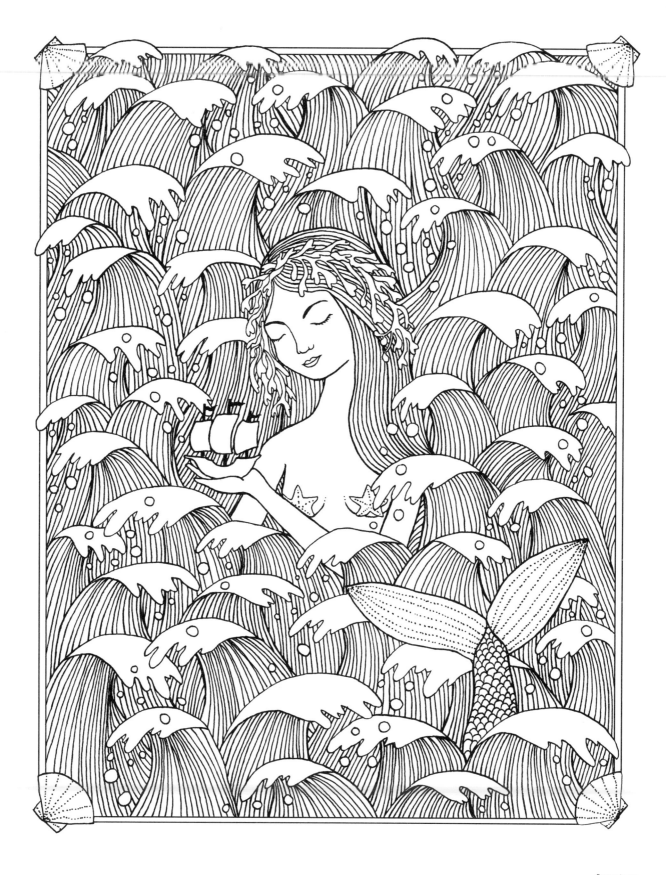

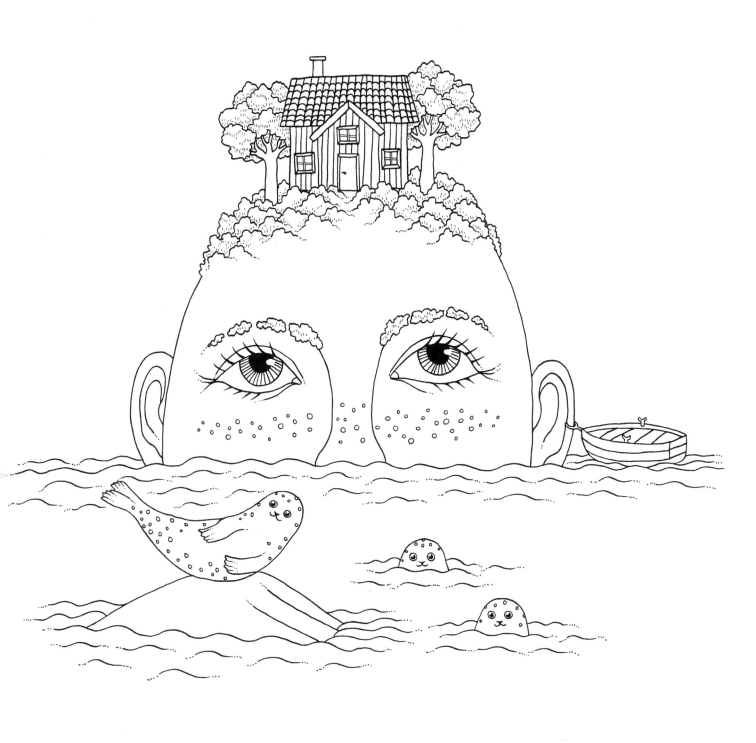

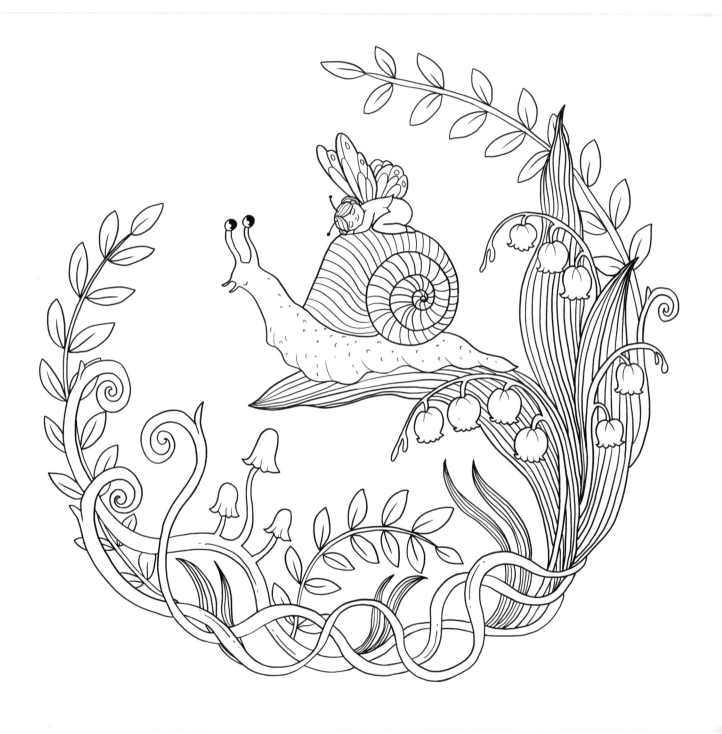

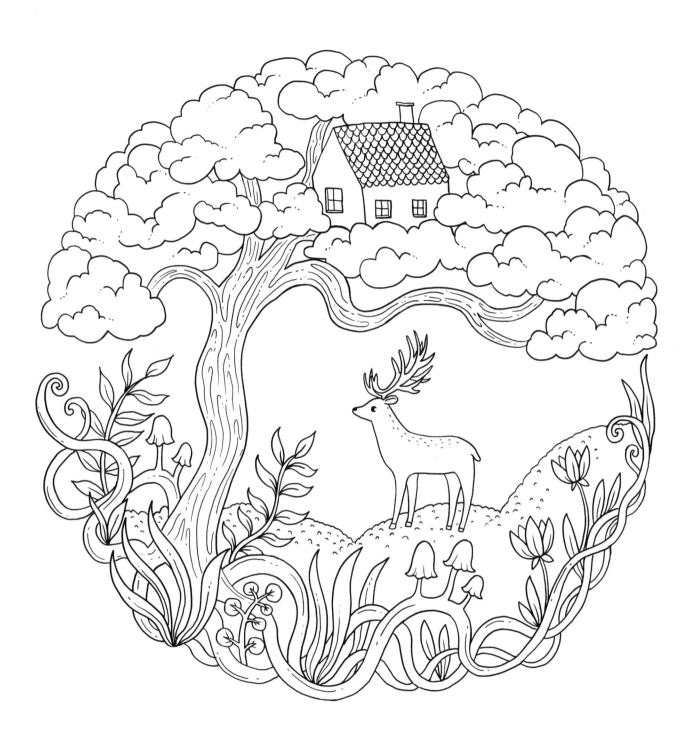

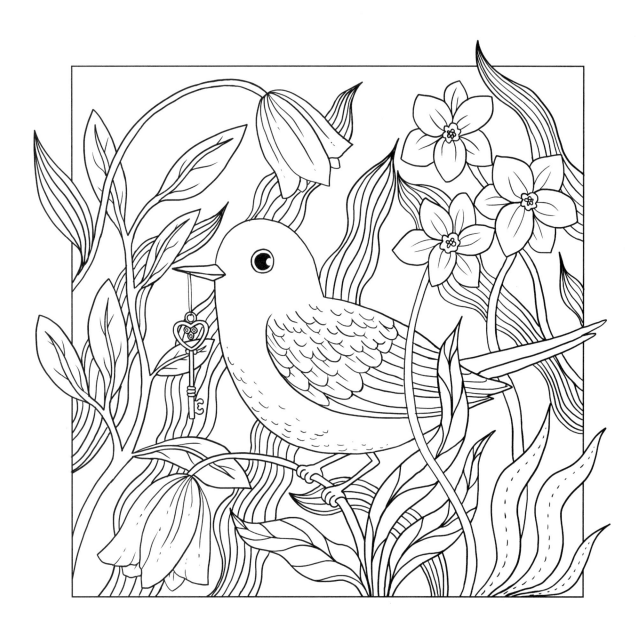

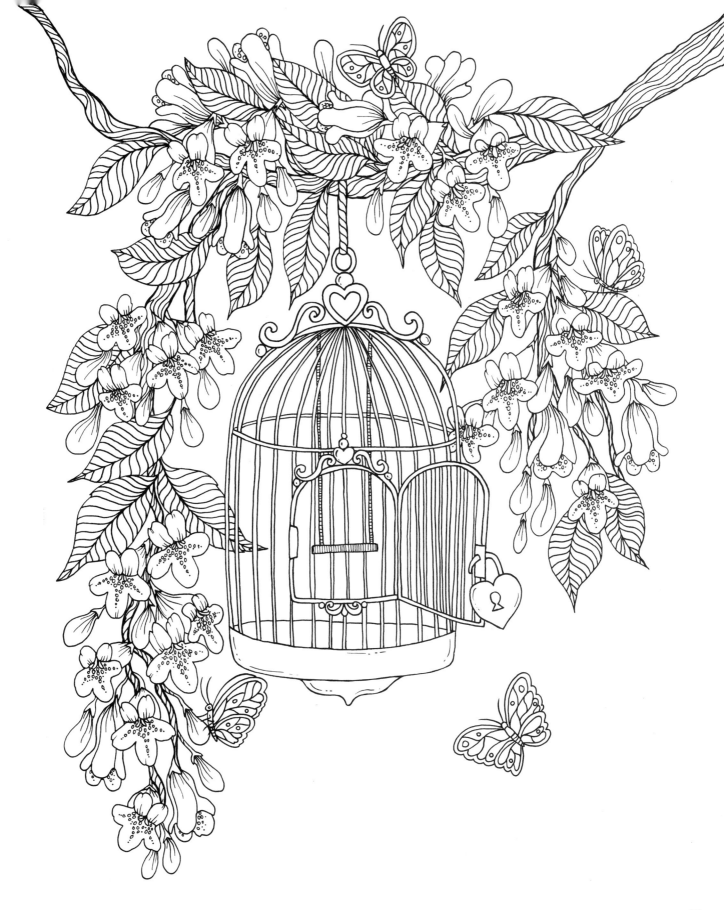

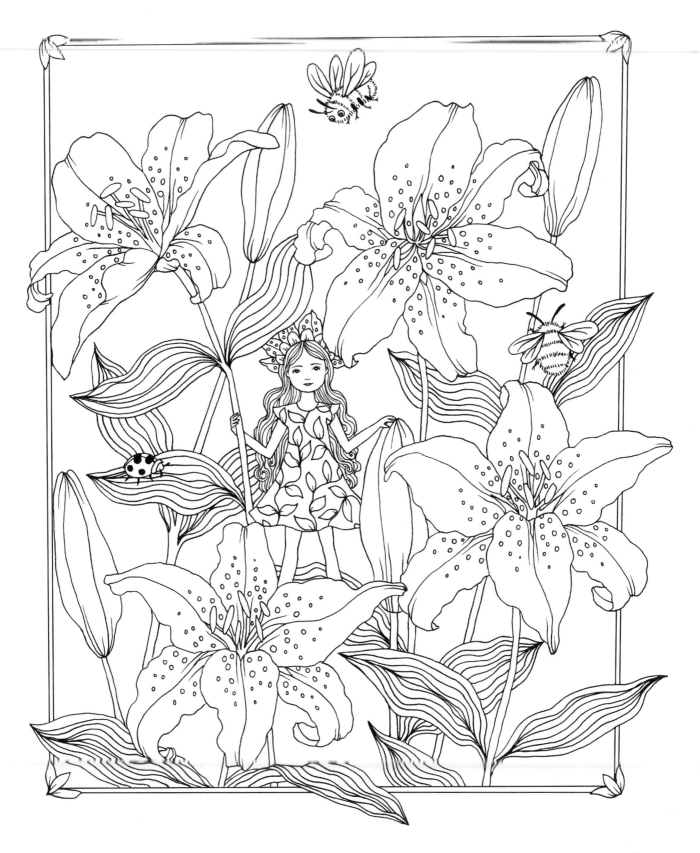

Flora

Twilight Garden

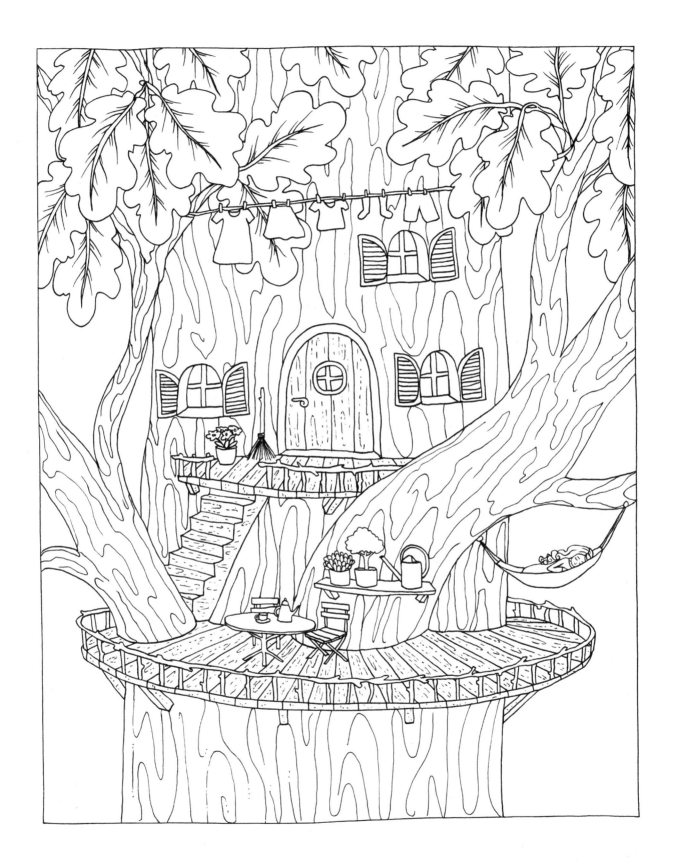

Flora

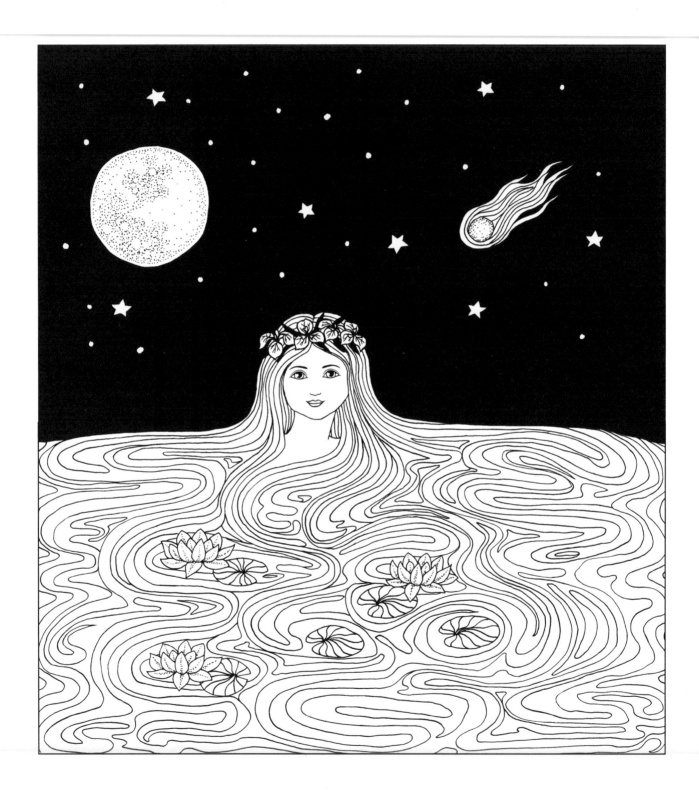

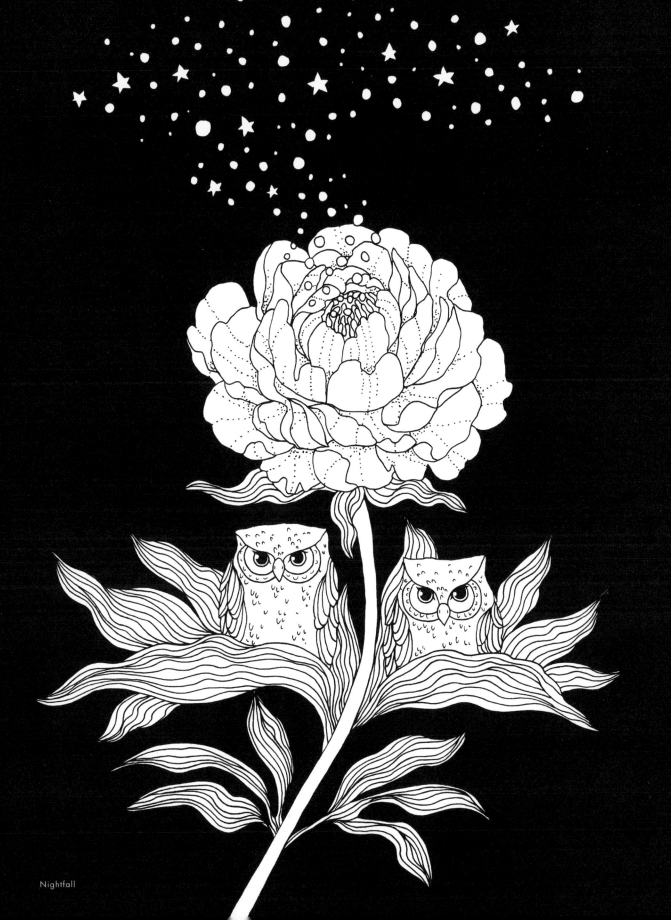

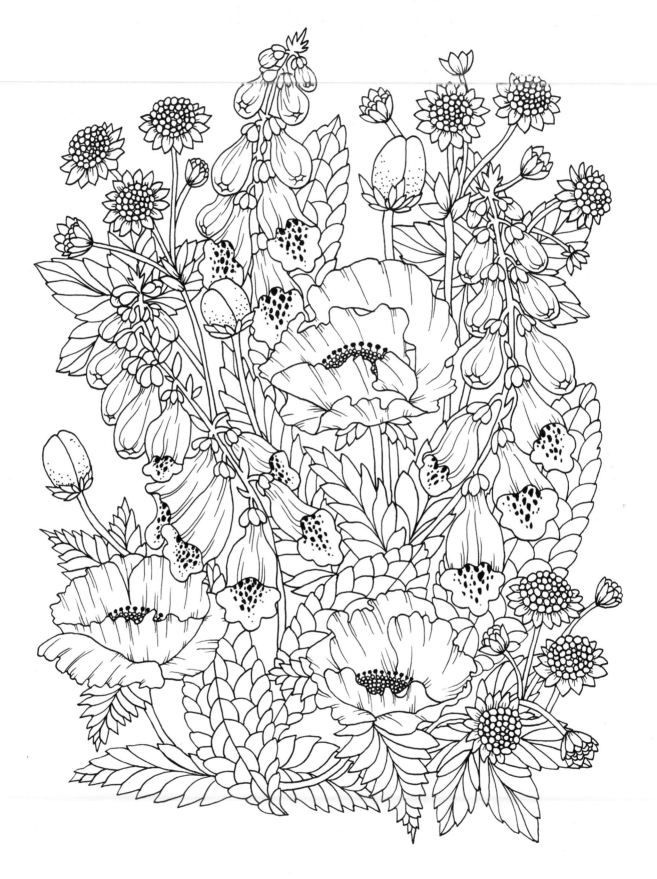

Twilight Garden

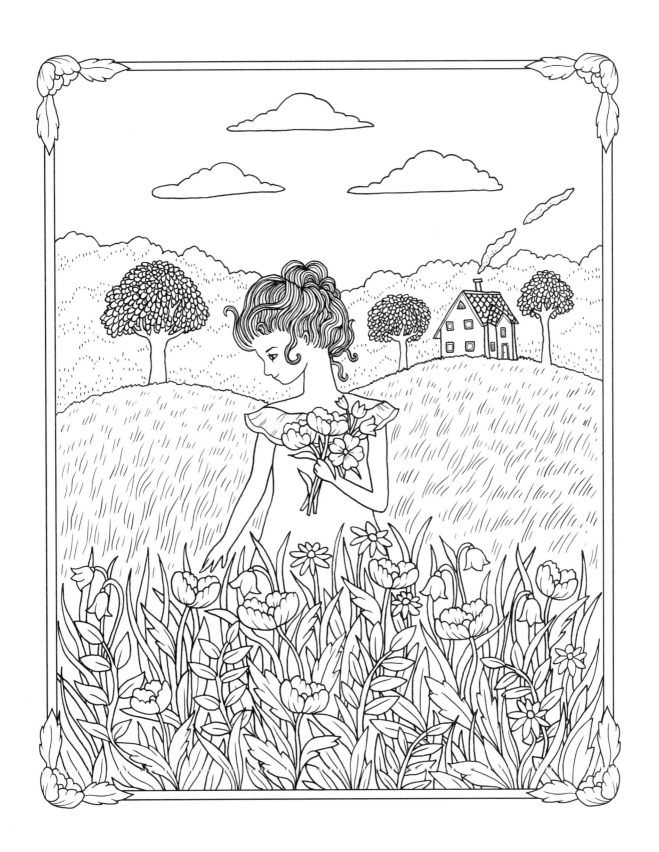

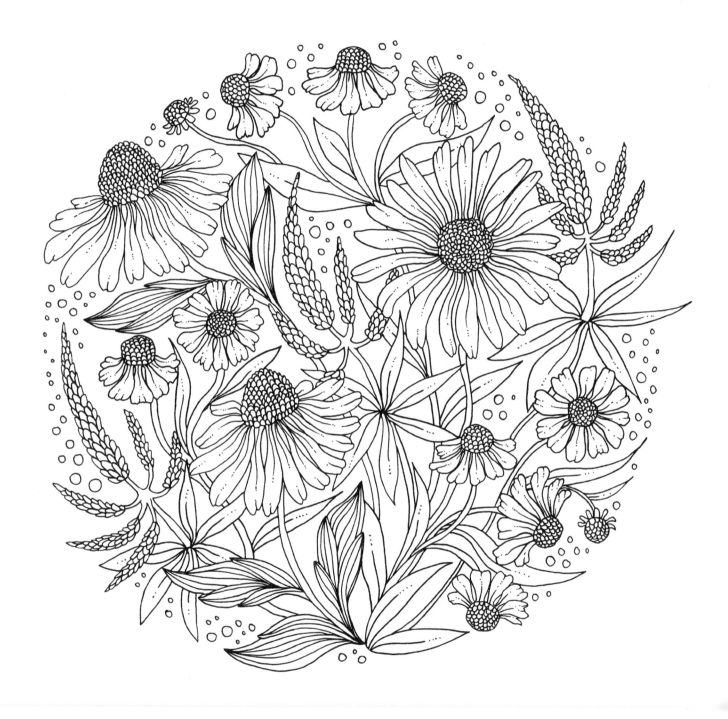

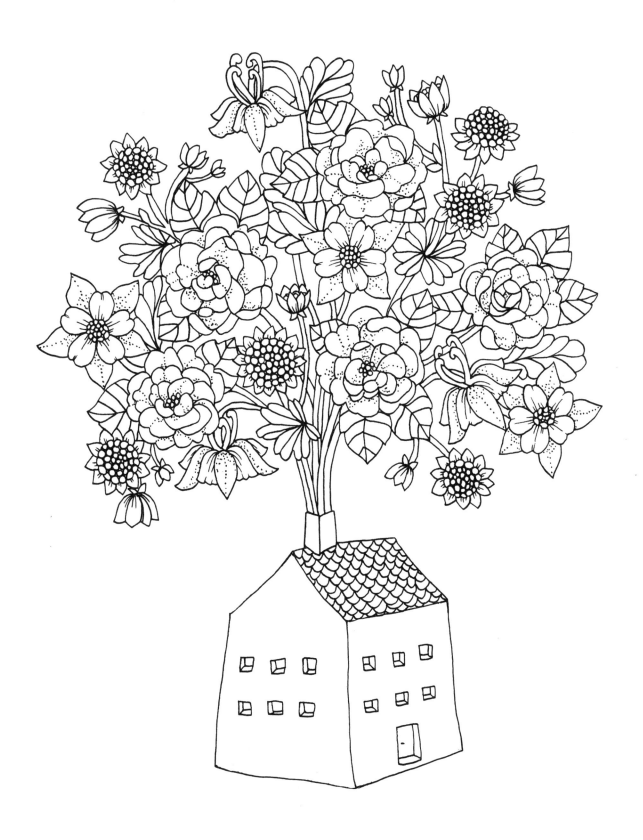

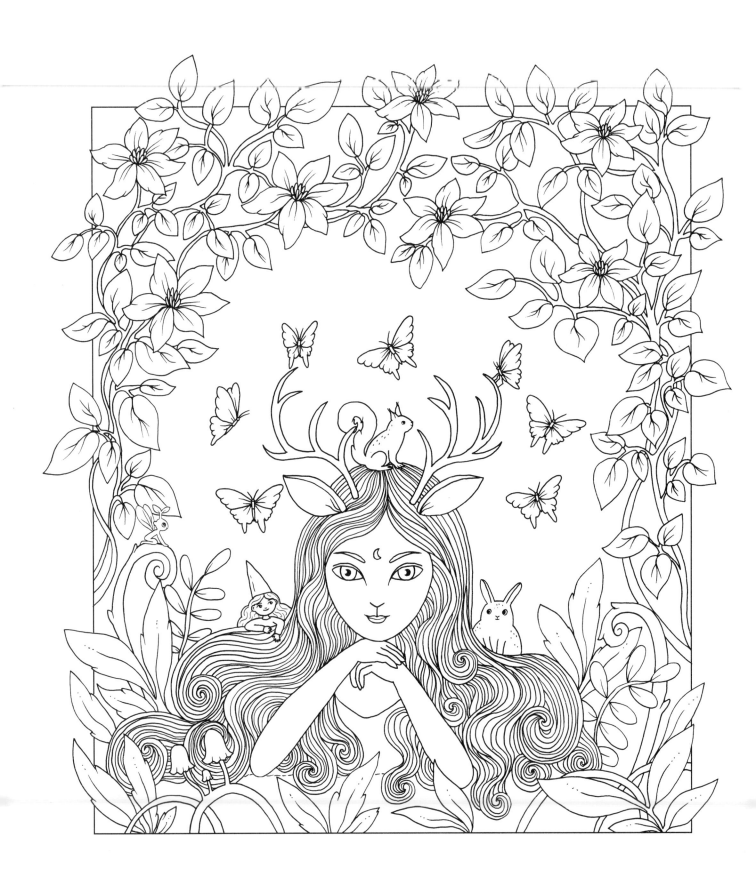

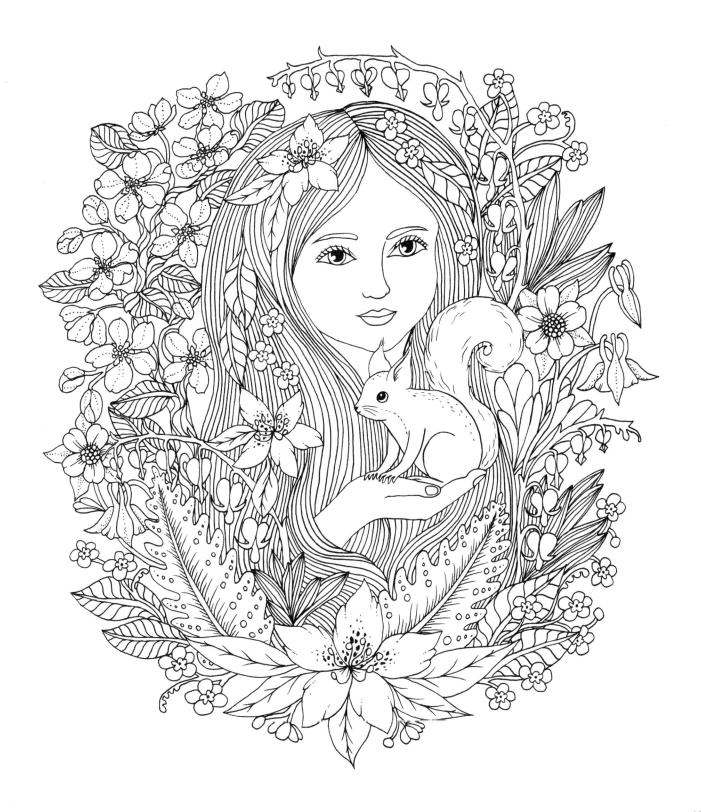

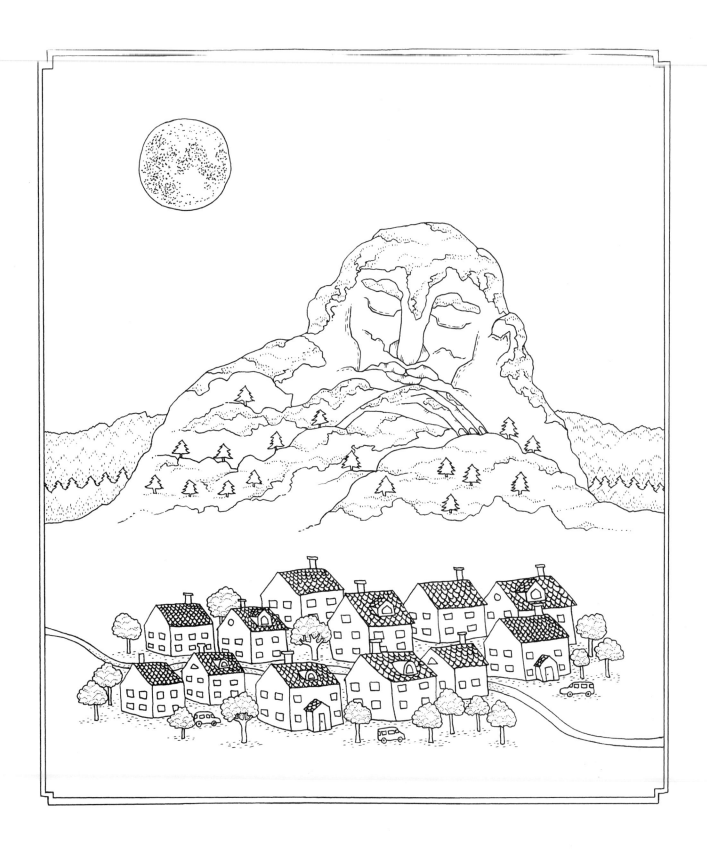

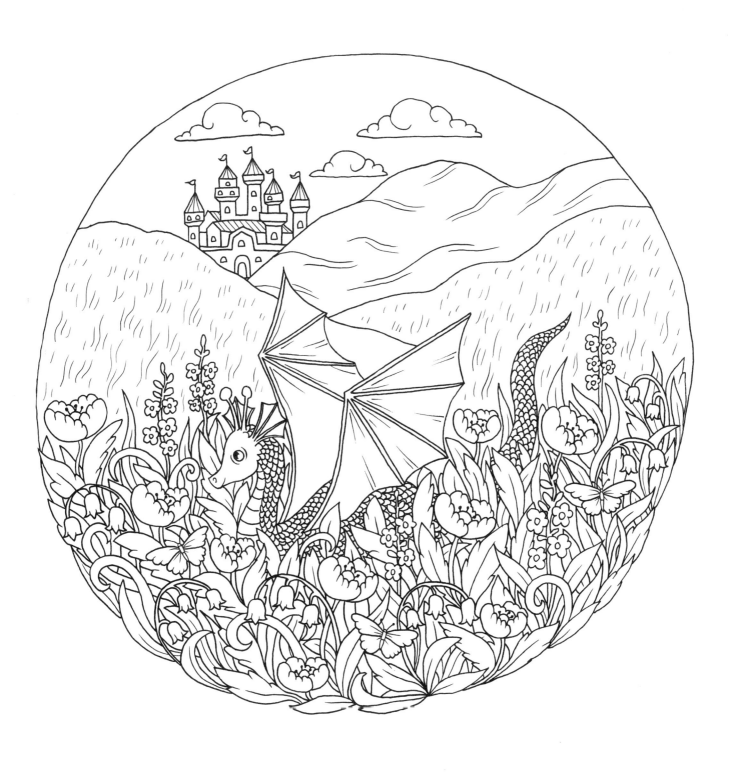

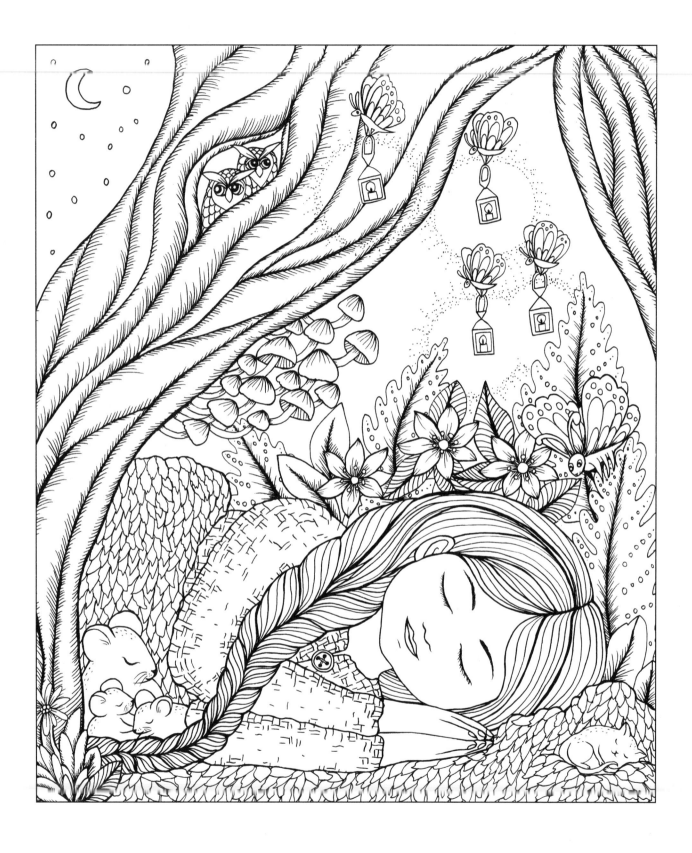

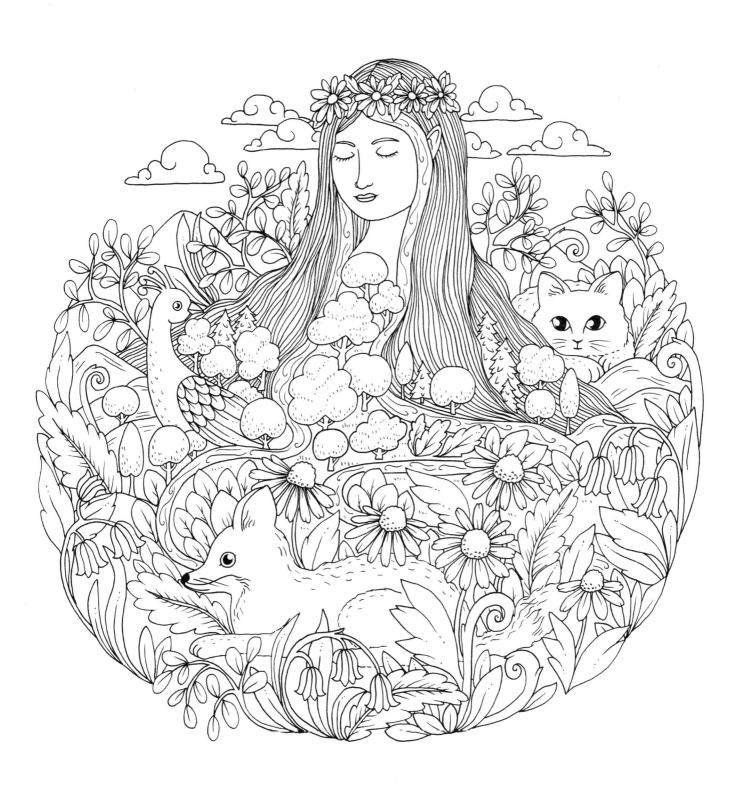

Moon Valley

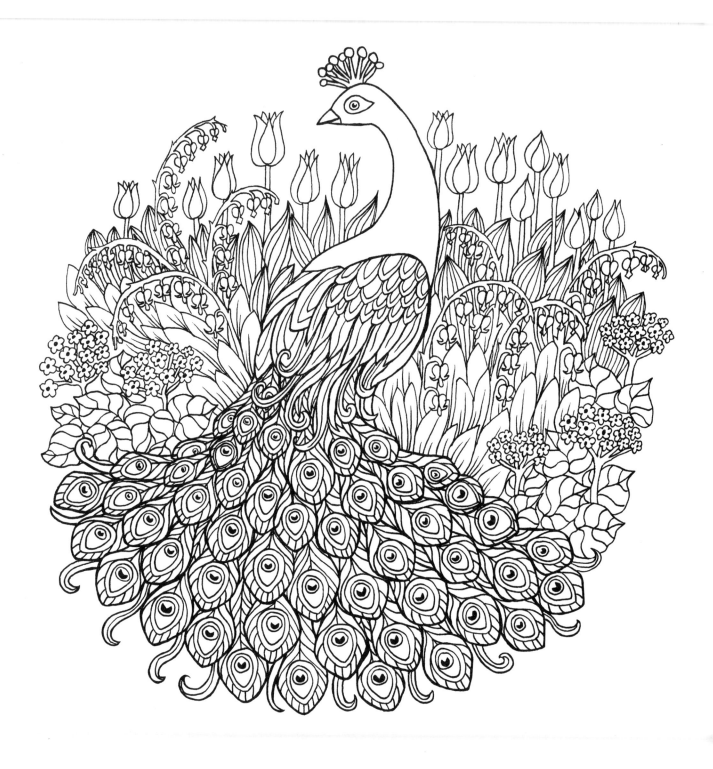

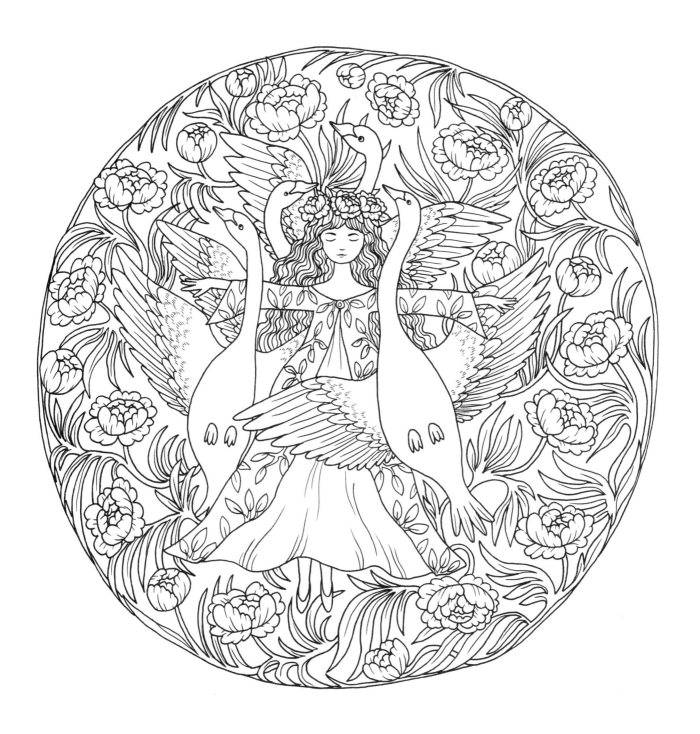

Luna

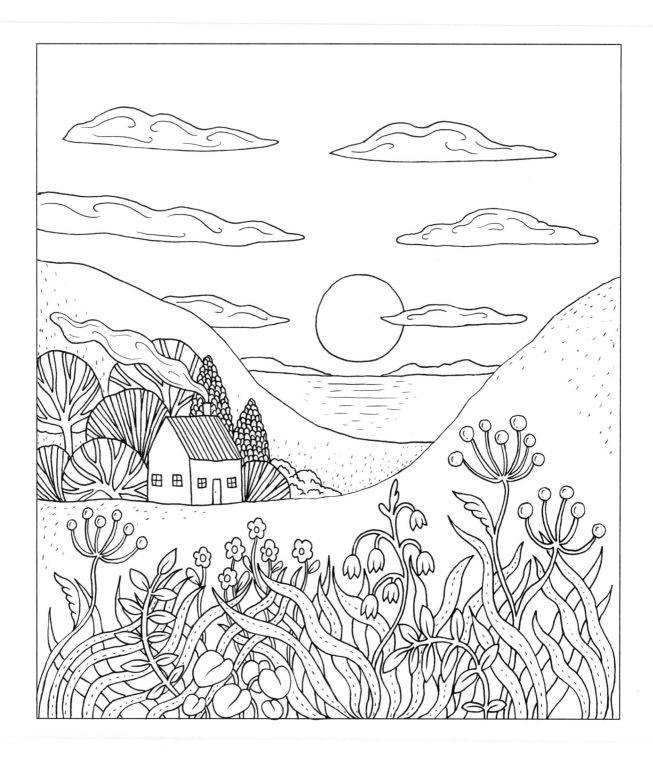

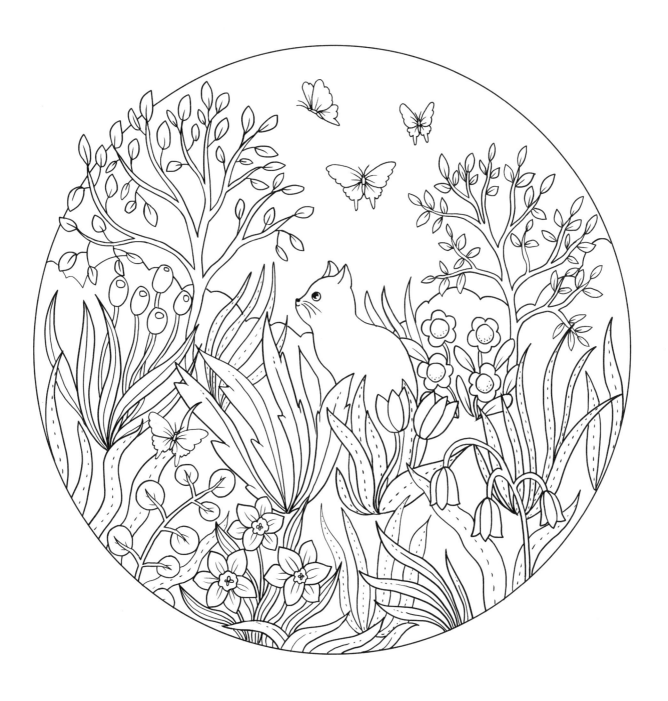

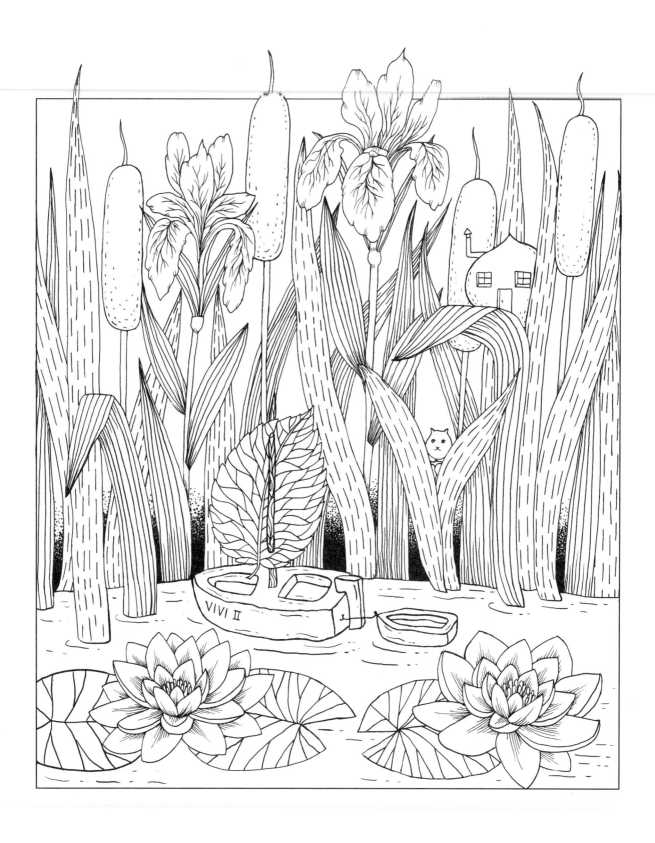

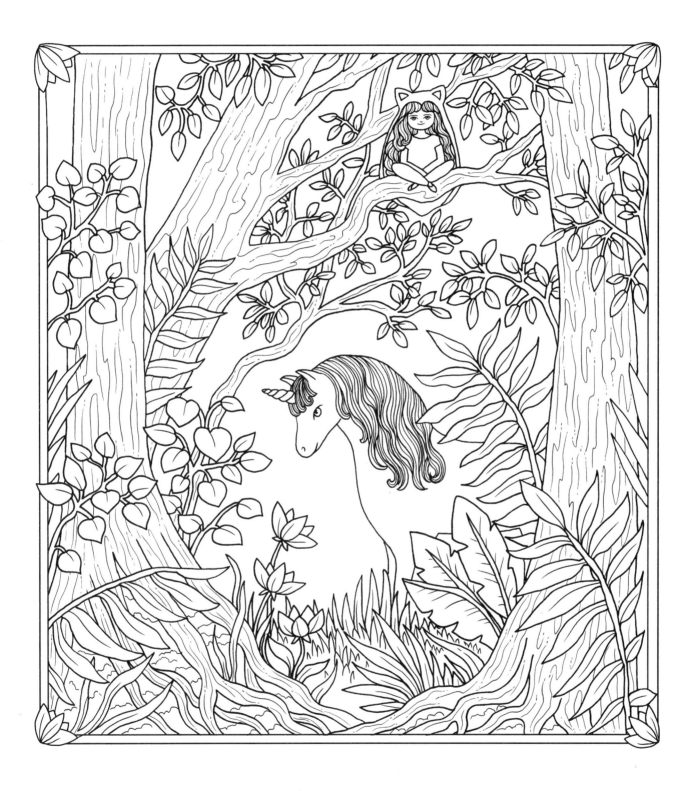

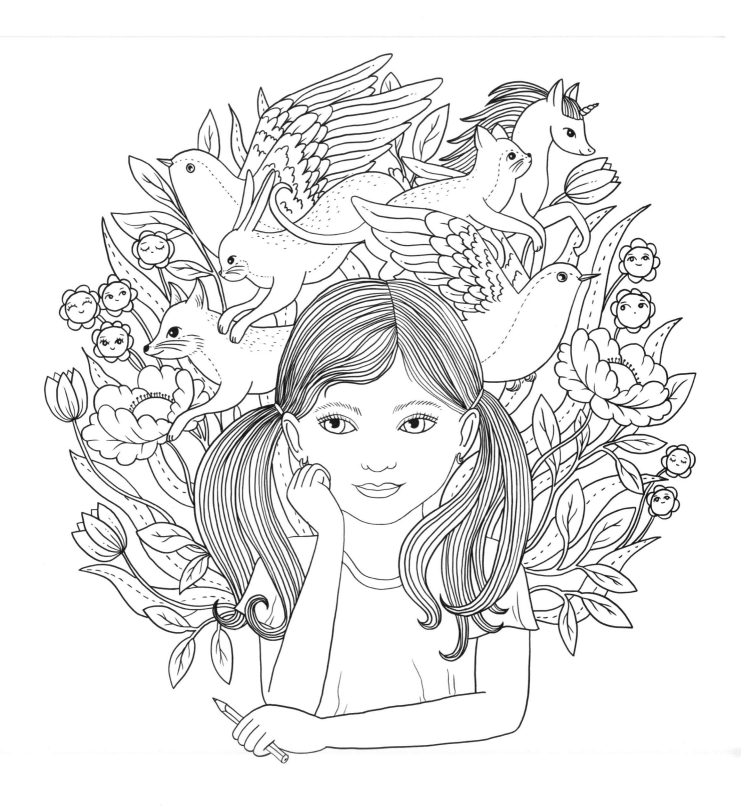

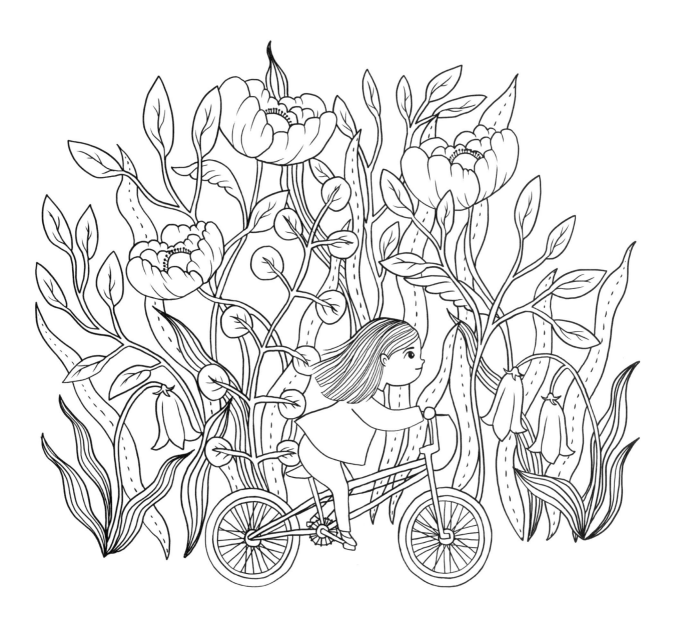

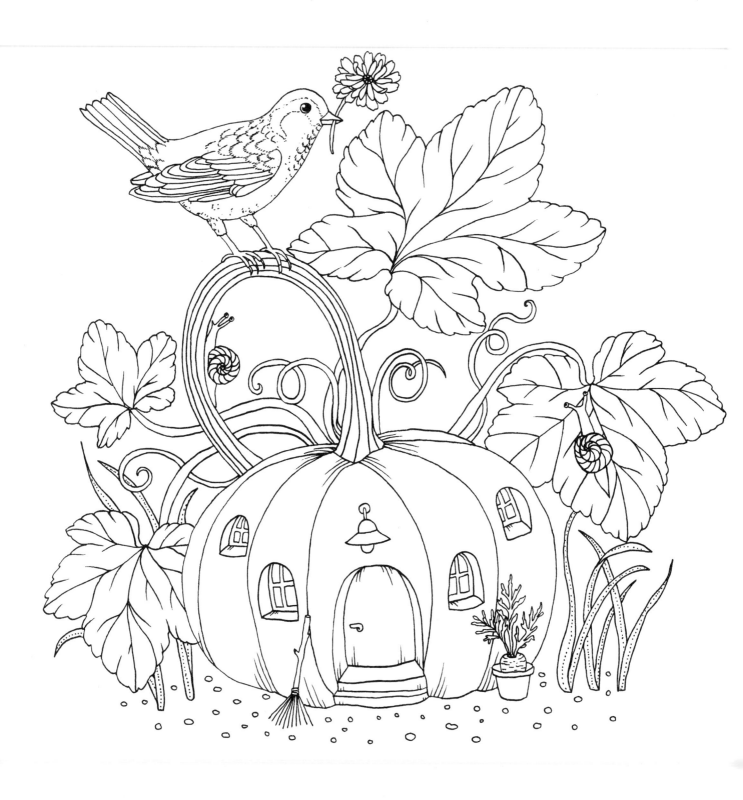

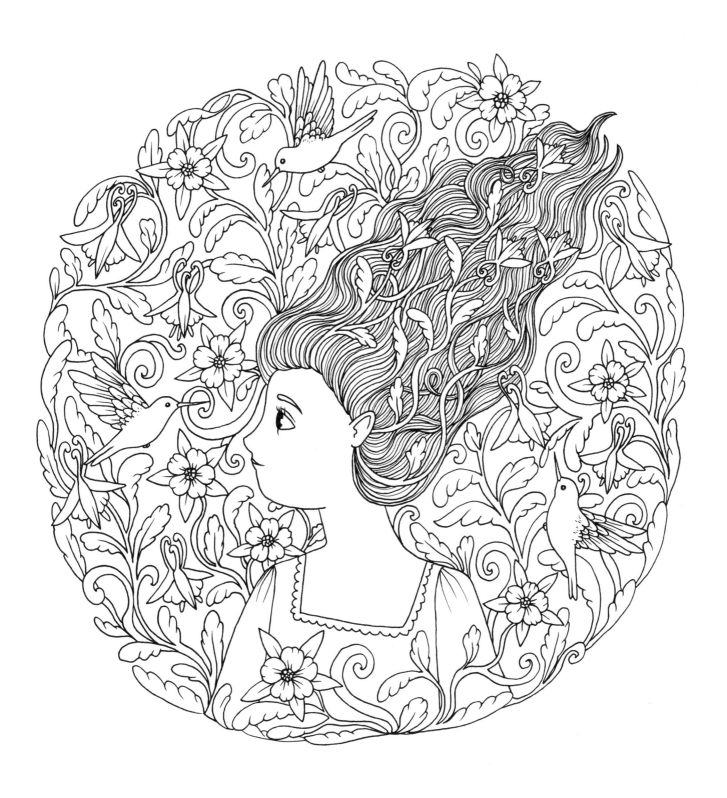

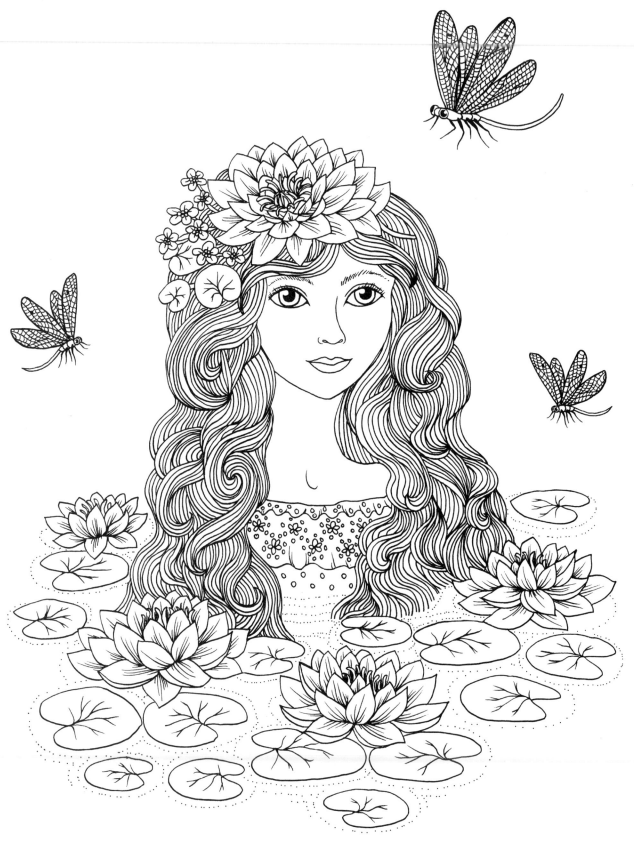

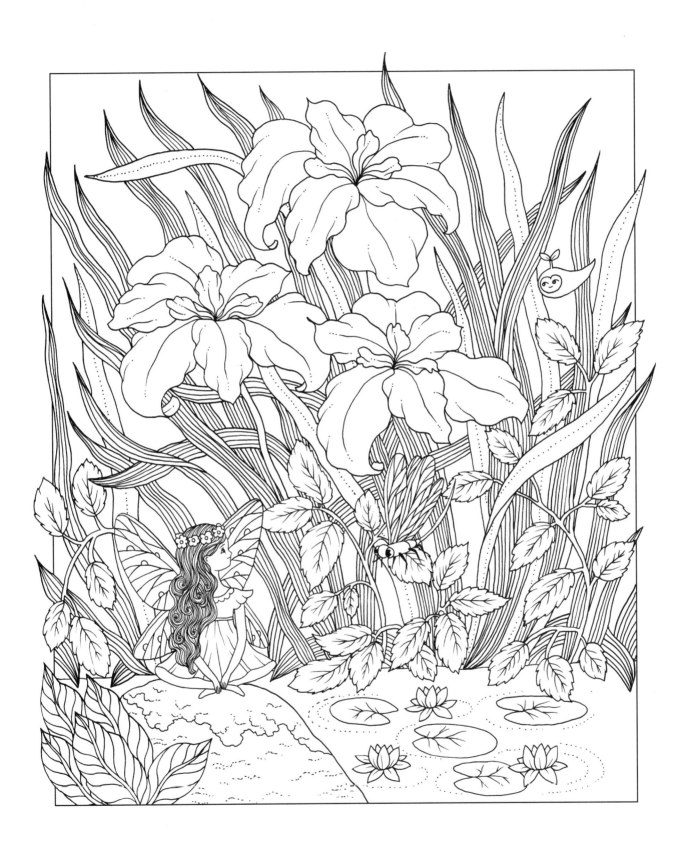

Luna

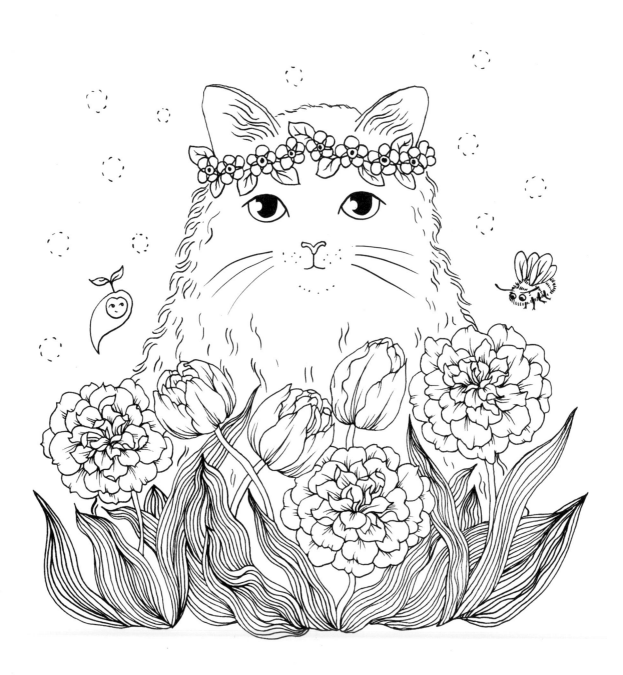

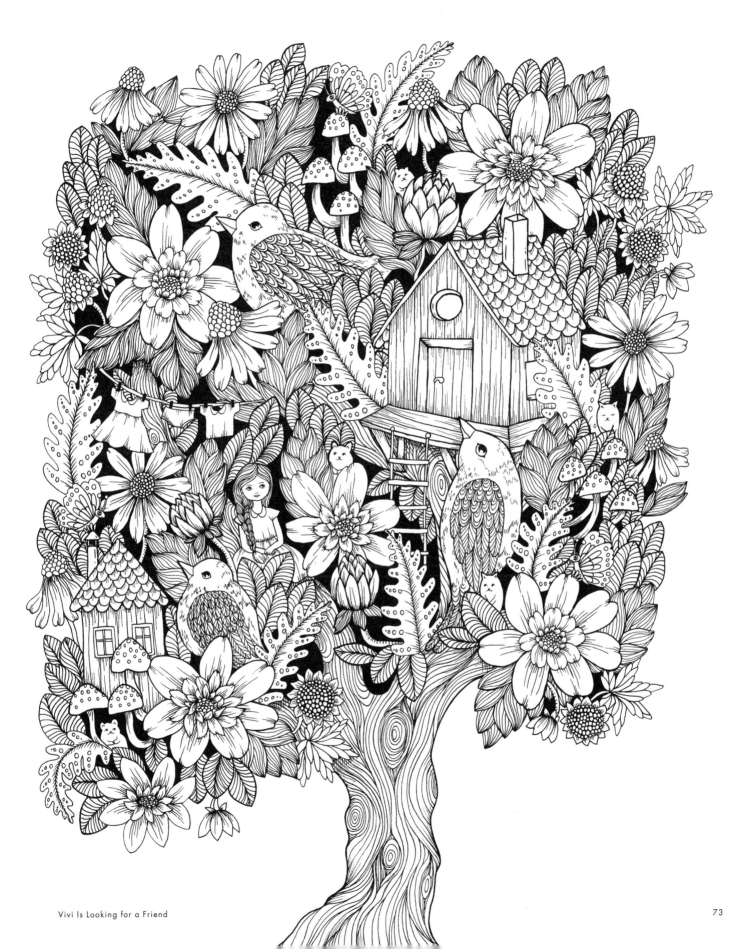

Vivi Is Looking for a Friend

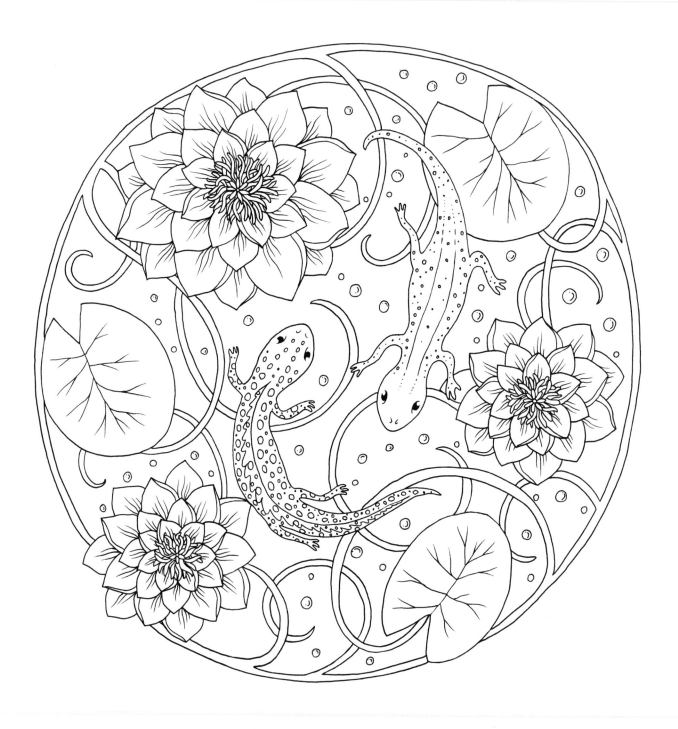

Vivi Is Looking for a Friend

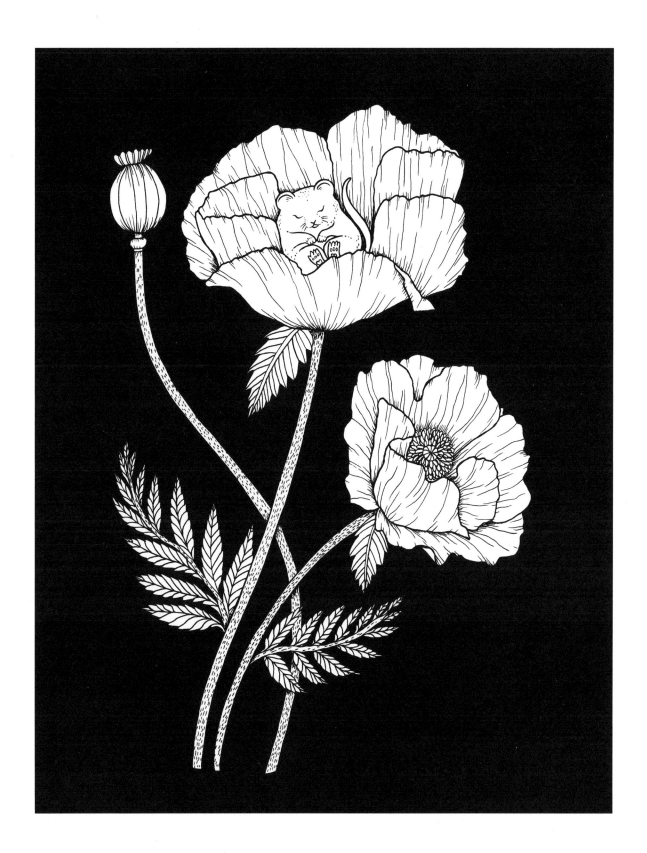

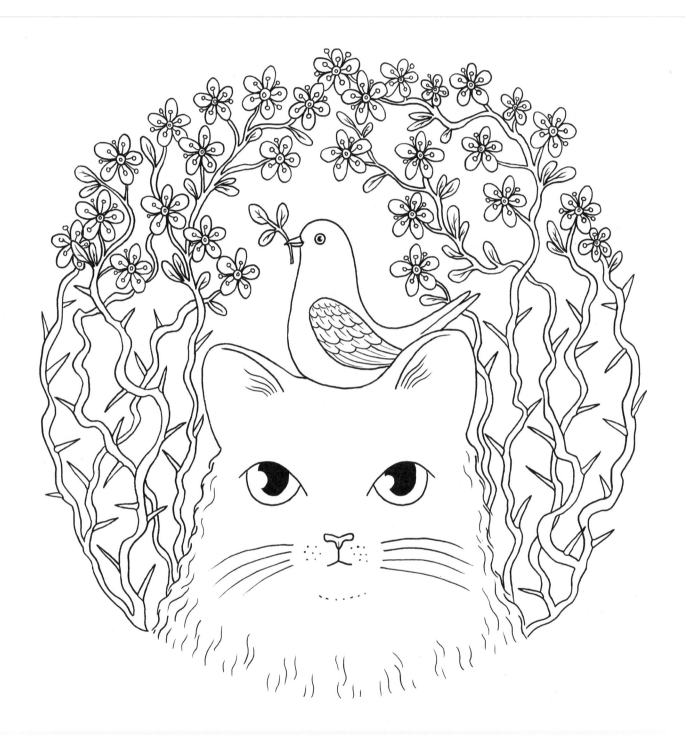

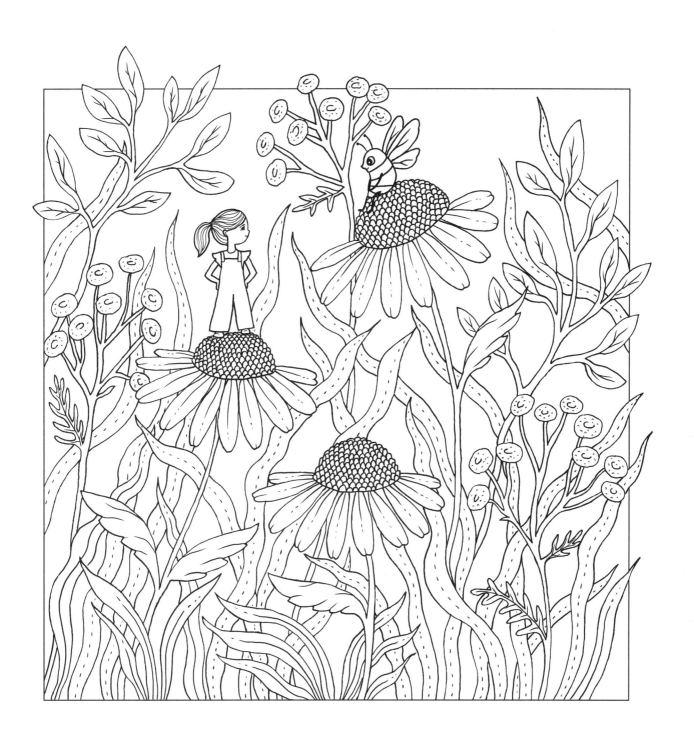

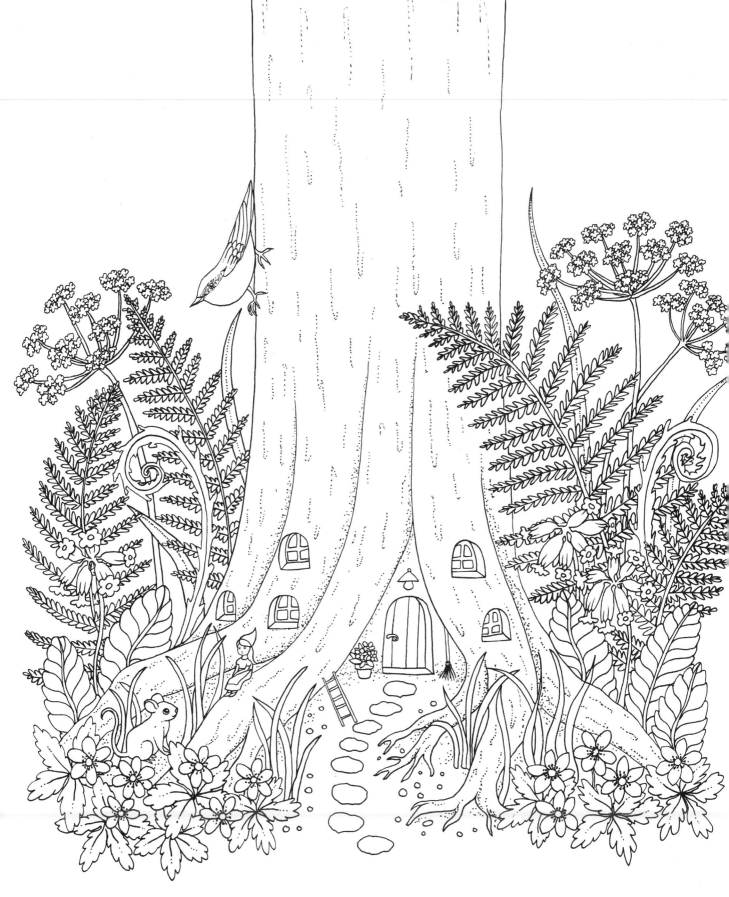

Moon Valley

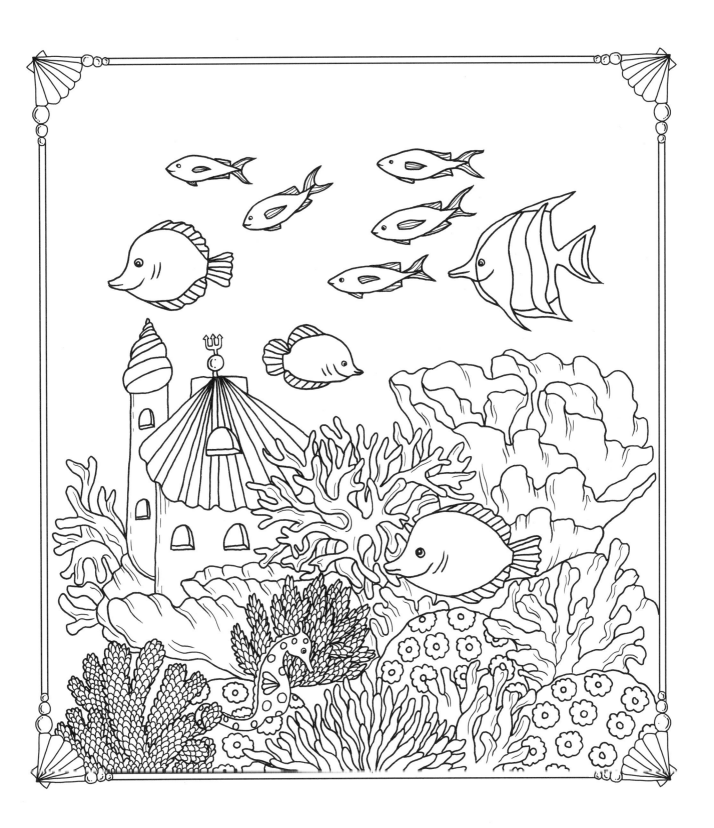

Luna

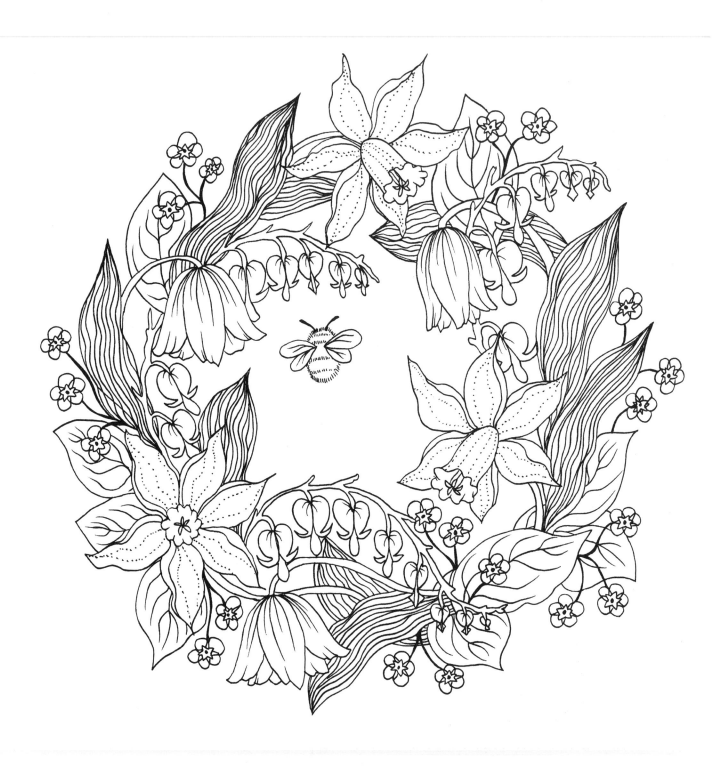

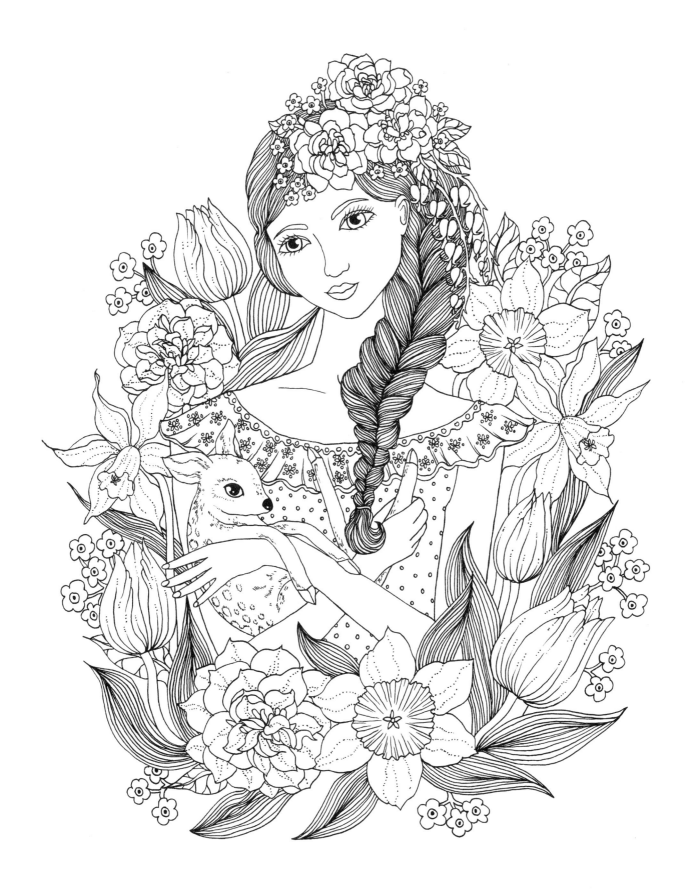

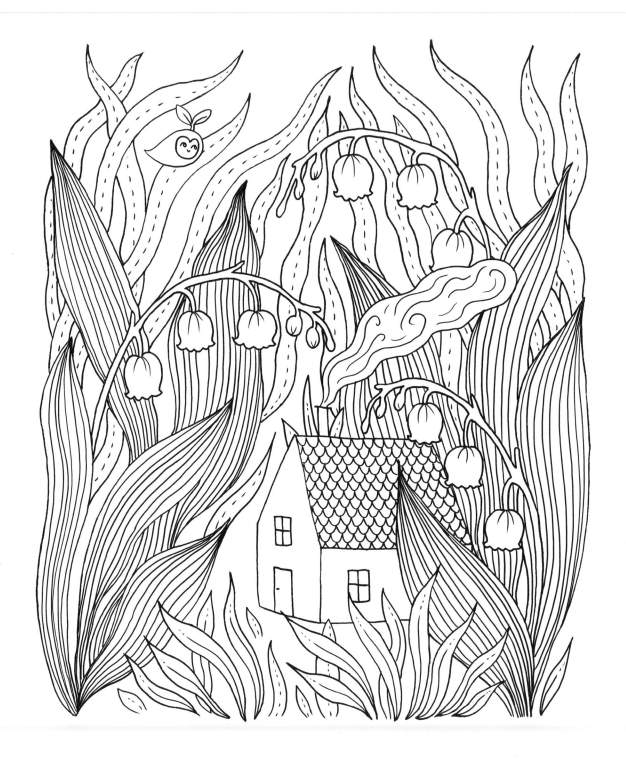

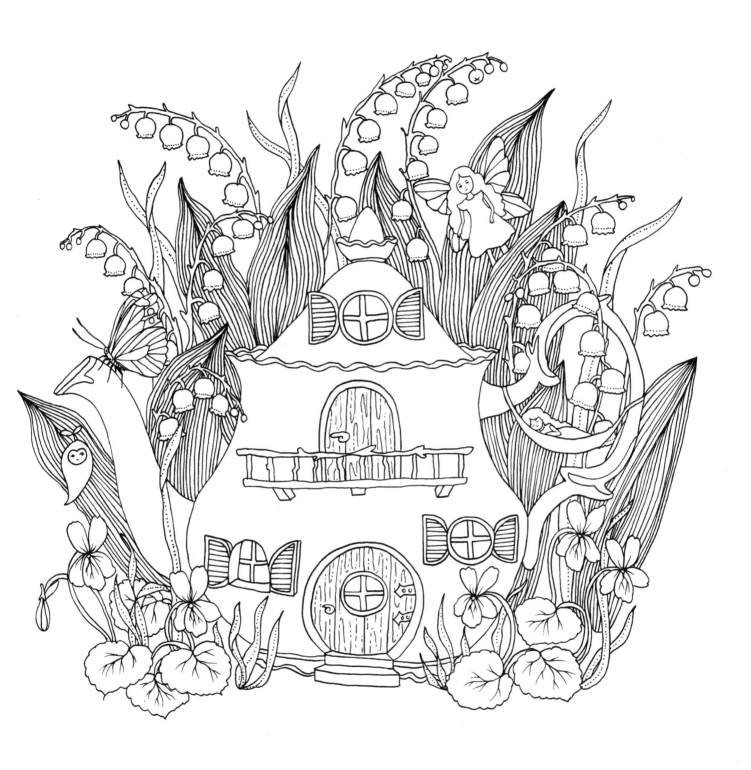

Flora

REGISTER OF PLANTS AND FUNGI

Some plants are made up and therefore not specified.

53	Aquilegia vulgaris
	Astrantia major
	Rosa 'The fairy'
54	Clematis 'Arabella'
	Coprinellus disseminatus
55	Lamprocapnos
	Malus domestica
	Omphalodes verna
	Rhododendron arborescens
	Aquilegia vulgaris
	Polypodium vulgare
56	No specified species
57	Papaver
	Campanula rotundifolia
58	Coprinellus disseminatus
	Polypodium vulgare
	Trientalis europaea
59	Echinacea purpurea
60	Tulipa 'Ballerina'
	Omphalodes verna
	Lamprocapnos
61	Paeonia
62	No specified species
63	Tulipa
	Narcissus poeticus
64	Nymphaeaceae
	Iris sibirica
65	No specified species
66	Tulipa
	Papaver
67	Papaver
	Campanula rotundifolia
68	Cucurbita maxima
69	Aquilegia vulgaris
70	Nymphaeaceae
	Caltha palustris
71	Nymphaeaceae
	Iris sibirica 'Moon silk'
72	Tulipa
	Narcissus 'Cheerfulness'
	Omphalodes verna
73	Dahlia
	Echinacea purpurea
	Polypodium vulgare
	Astrantia major

74	Nymphaeaceae
75	Coprinellus disseminatus
76	Magnolia
	Nymphaeaceae
77	Paeonia
78	Dahlia
	Echinacea purpurea
	Polypodium vulgare
	Astrantia major
79	Papave
80	Prunus spinosa
81	Tanacetum vulgare
	Echinacea purpurea
82	Anemone nemorosa
	Athyrium filix-femina
	Primula veris
	Anthriscus sylvestris
83	Dahlia
	Coprinellus disseminatus
	Anemone hupehensis
	Vaccinium myrtillus
	Corylus avellana
84	Helianthus annuus
85	Rosa rugosa
	Myosotis scorpioides
	Trifolium pratense
	Dianthus deltoides
	Campanula rotundifolia
86	Anemone nemorosa
	Convallaria majalis
87	No specified species
88	Omphalodes verna
	Tulipa
	Lamprocapnos
	Narcissus triandrus 'Thalia'
89	Tulipa
	Omphalodes verna
	Narcissus 'Cheerfulness'
	Narcissus triandrus 'Thalia'
	Narcissus pseudonarcissus 'Ice follies'
	Lamprocapnos
90	Convallaria majalis
91	Convallaria majalis
	Viola riviniana

REGISTER OF ANIMALS

To my Family

27 26 25 24 23 5 4 3 2 1

Universe Coloring Book
Illustrations © 2022 Maria Trolle
www.mariatrolle.se
Instagram: @maria_trolle

Original title: *Maria Trolles Universum – målarbok*
Swedish edition copyright © 2022 Bookmark Förlag, Sweden.
All rights reserved.

English edition copyright © 2023 Gibbs Smith Publisher, USA.
Published by agreement with Ferly.

Gibbs Smith
P.O. Box 667
Layton, Utah 84041

1.800.835.4993 orders
www.gibbs-smith.com

ISBN: 978-1-4236-6516-8